REAL CITY

Downtown Los Angeles

INSIDE / OUT

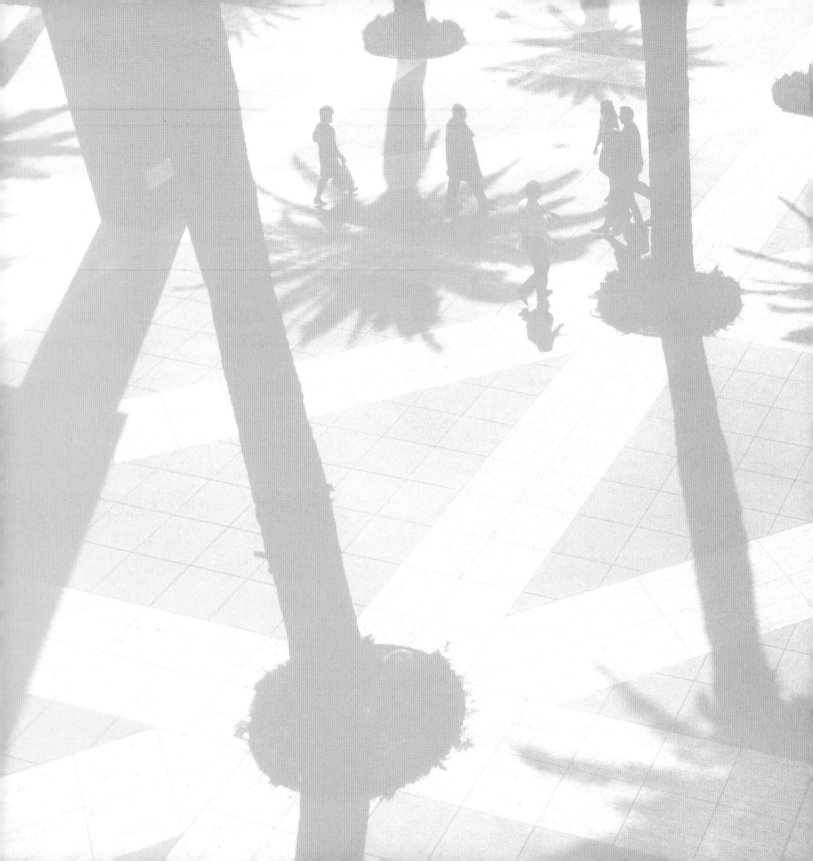

REAL CITY

Downtown Los Angeles

INSIDE / OUT

PHOTOGRAPHS BY **Marissa Roth** TEXT BY D. J. WALDIE

ANGEL CITY PRESS

ANGEL CITY PRESS
2118 Wilshire Blvd., #880
Santa Monica, California 90403
310.395.9982
www.angelcitypress.com

Real City : Downtown Los Angeles Inside/Out
photographs by Marissa Roth
Text by D.J. Waldie
Photographs copyright © 2001 by Marissa Roth and the Los Angeles Public Library
Text copyright © 2001 by Donald J. Waldie
Afterword copyright © 2001 by Marissa Roth
Design by Maritta Tapanainen

First edition
10 9 8 7 6 5 4 3 2 1

ISBN 1-883318-07-6

LIBRARY OF CONGRESS CATALOGING-IN-PUBLICATION DATA

Roth, Marissa.
Real city : downtown Los Angeles inside/out / photographs by Marissa Roth ;
text by D.J. Waldie.—1st ed.
 p. cm.
ISBN 1-883318-07-6 (hardcover : alk. paper)
1. Los Angeles (Calif.)—Pictorial works. 2. Central business districts—
California—Los Angeles—Pictorial works. 3. Los Angeles (Calif.)—Description
and travel. 4. Los Angeles (Calif.)—Social conditions. I. Waldie, D. J. II. Title.
F869.L843 R68 2001
779'.99794'94—dc21
 2001003381
 CIP

Printed in China

In memory of my mother and father,

Margaret Roth and George Roth

— M.R.

INTRODUCTION

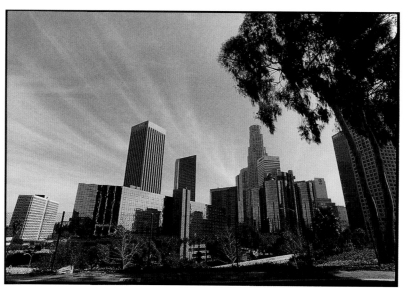

A view of the downtown skyline from Beaudry Avenue

COLONIAL CITY. CAPTURED CITY. CITY OF EDGES. MESTIZO CITY. CITY OF AMNESIACS. ANXIOUS CITY. THE CITY OF LOS ANGELES. Its founding elements were the simplest: air, earth, sunshine, and too little water. Notice that lack. Los Angeles was perilously close to perfection when California's Spanish governor sketched its outline in a notebook in 1781. Only a little more water — or more money or power or speed or distance — would render this unlikely place adequate to the demands of our desire, even if what we desired was continually reinvented.

Desire cast off a succession of cities over the next two hundred twenty years. Some of the cities were real; some are mythological. Los Angeles is an archipelago of cities. They crowd our real and imagined landscapes and invite an easy placelessness — no place more so than L.A.'s downtown.

From its conception, the center of the city had rivals. The new pueblo that clustered around the plaza was a secular town. Its religious heart was ten miles away at Mission San Gabriel, whose Franciscan priests were suspicious of the pueblo's heterogeneous mix of races and conditions even before the town's first settlers arrived. Los Angeles didn't have its own church until 1822.

By then, the mission system was ending and California was a Mexican province. The sale of hides and tallow to Boston merchants made comfortable lives for *rancheros* in scattered haciendas. Downtown, penned in a corral near the Calle de los Negroes to sober up, the town's Gabrieleño Indians waited on Monday mornings to be auctioned off to the *rancheros* for another week of hard labor. The

workers' pay was the cost of the local mescal it took to get them drunk and corralled again on Saturday night.

That downtown persisted through the American occupation of the city in 1847 and the boom that began with the Gold Rush and ended with drought and the collapse of the cattle economy in the mid-1860s. Pastoral Los Angeles — intensely romanticized and profoundly anti-urban — became the city's sales pitch after the 1884 publication of Helen Hunt Jackson's *Ramona*. Jackson had wanted to indict Angelenos for their treatment of the city's Indian and mestizo residents. L.A.'s boosters wanted only the exoticism of the city's rapidly disappearing Hispanic past. Their success put a paradox at the center of the city. Downtown was now the place you came to by train from Iowa or Illinois looking for a mythic Los Angeles, only to find an ordinary prairie town set improbably in the desert.

A new, American downtown grew out with waves of middle-aged Midwesterners who couldn't go back after their *Ramona*-inspired romance ended. They changed the Spanish names of the downtown streets, their compass orientation, and their relationship to the surviving landscape of river and flood plain. They wouldn't change the city's addiction to speed. Steam railways in the 1880s made Los Angeles sprawl along the mainline tracks from the East. Henry Huntington's network of electric trolleys accelerated the city's suburban dispersal after 1901. The automobile in the 1920s filled downtown's department stores and million-dollar movie theaters along Broadway. And just as fast, the automobile unmade downtown. The depression of the 1930s, the Second World War, post-war suburbanization, the new freeway, and newer immigrants from Asia, Mexico, and South America put downtown at an increasing distance from the millions who now lived in suburban Los Angeles.

My father worked for much of his career as an engineer with the Southern California Gas Company at its headquarters on Flower Street. When I was a boy in the 1950s living in Lakewood, my father's downtown seemed as remote as a city in the East. We ate once or twice at a downtown cafeteria and went once or twice to see a road show musical at the old concert hall. I never saw my father's downtown as the center of anything, except in the moody, noir films of that era, where downtown looked like the capital city of regret.

Redevelopment in the 1960s and 1970s brought the erasure of downtown's working-class neighborhoods and their sense of place. Downtown was remade as an island of government bureaus, high-rise offices, and disconnected trophy projects like the Music Center. That downtown emptied every night, except for the transient, the homeless, and the immigrant families, documented or not, who struggled to fit their dreams into the city's grid. The working poor walked downtown's booming *mercado* along Broadway, worshiped in the plaza church or storefront *iglesias*, and labored in garment district sweatshops. Above them hovered an alternative downtown of CEOs in their corporate headquarters. In the recession of the 1990s, they also drained away.

The downtown that remains superimposes and blurs all of these places. You can see how, in Marissa Roth's exceptional photographs, we've fitfully reimagined the eighteenth-, nineteenth-, and twentieth-century downtowns that coexist here, even as we desire to build another for a new century of even greater speed. It may be no more adequate than any of its predecessors, but at least this downtown is becoming a neighborhood again to working-class residents, as it never was for the past half-century. It's begun to pull down some of the barriers of race and ethnicity that conceal its true history. Downtown is worth wandering in, as Roth shows, if only to recover more of our public selves in this intensely private city.

Downtown has rarely been this city's center, because Los Angeles has never had a place of completion. The center we wanted was always elsewhere or in another time. In our longing, we tried to build them all from elemental air, earth, and sunshine...and hope, too. What we are making of our place today is as flawed and optimistic as we've always been and just as mixed. This is the value of Roth's clear-eyed and sympathetic photographs. They make our fractured, mestizo downtown memorable. These durable memories resist this city's habit of deliberate forgetting.

— D. J. Waldie

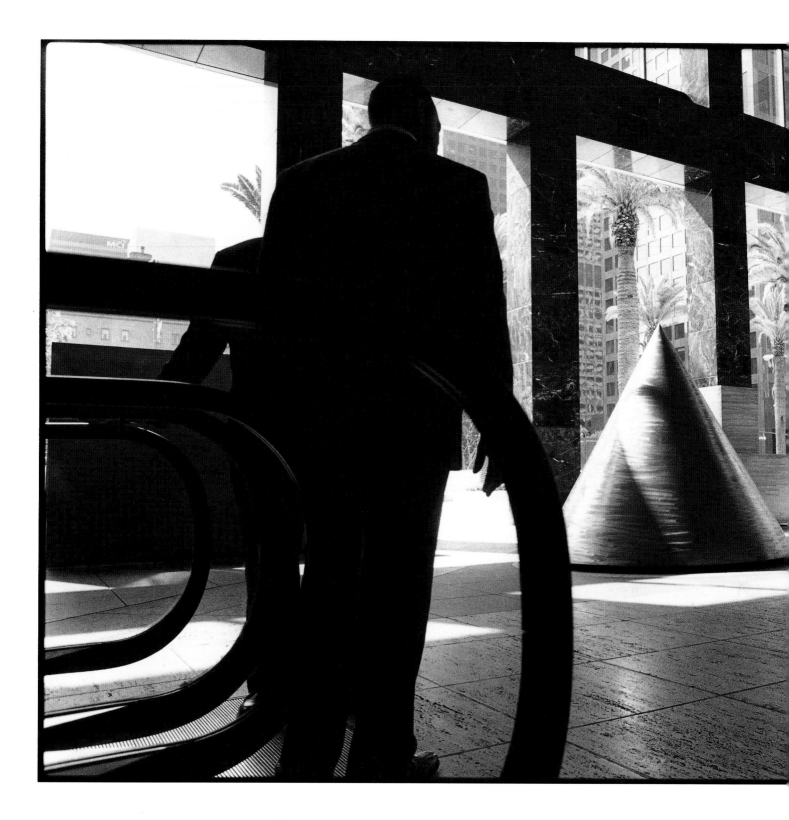

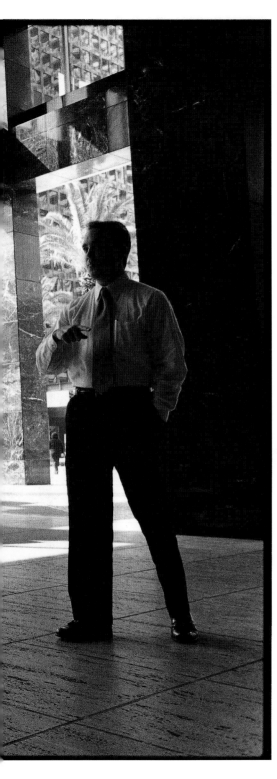

DOWNTOWN HAS A CROOKED HEART.
It's cocked
about 36 degrees from the rigid
north-south grid that was Thomas
Jefferson's rational dream for filling
all the empty places on the map of
America. Downtown's streets have
their own reasons. They do not
lead to the cardinal points of the
compass, as do the principal streets
in nearly all American cities, but to
the uncertain spaces in between.

LOOK AT A MAP
of Los Angeles and
you'll see what I mean. Within
the triumphant national grid that
extends across the plain of the
Los Angeles River lies the grid of
another city, four Spanish leagues
square, oriented to other memories.

[Impromptu business meeting, Citibank Plaza Courtyard at 5th and Flower Streets

[Overleaf: A back-lit journey on the 7th Street bus

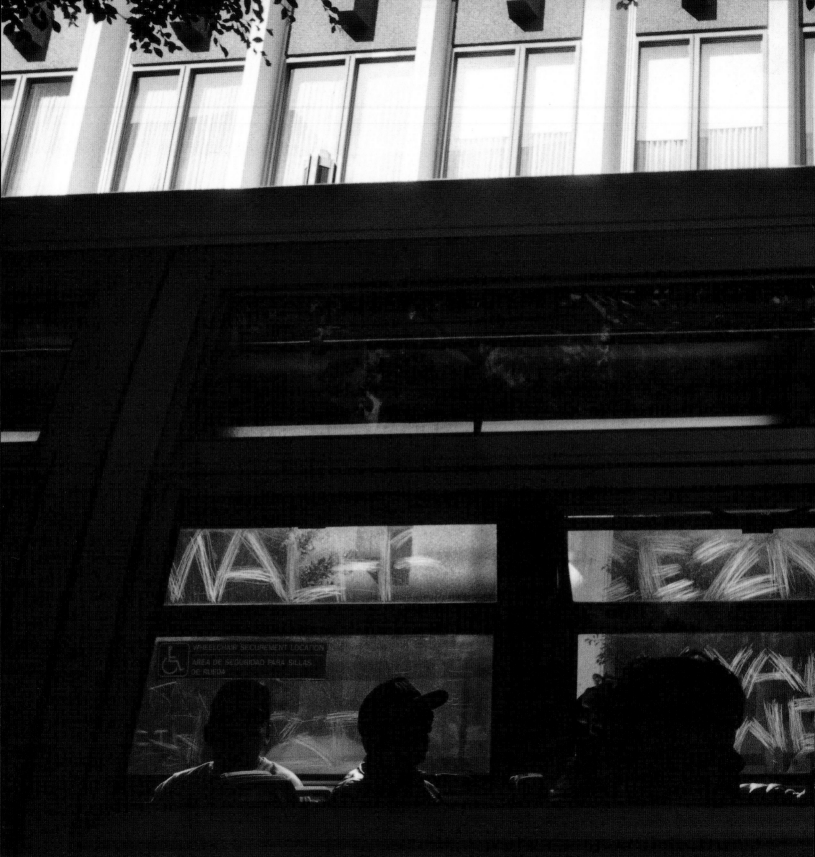

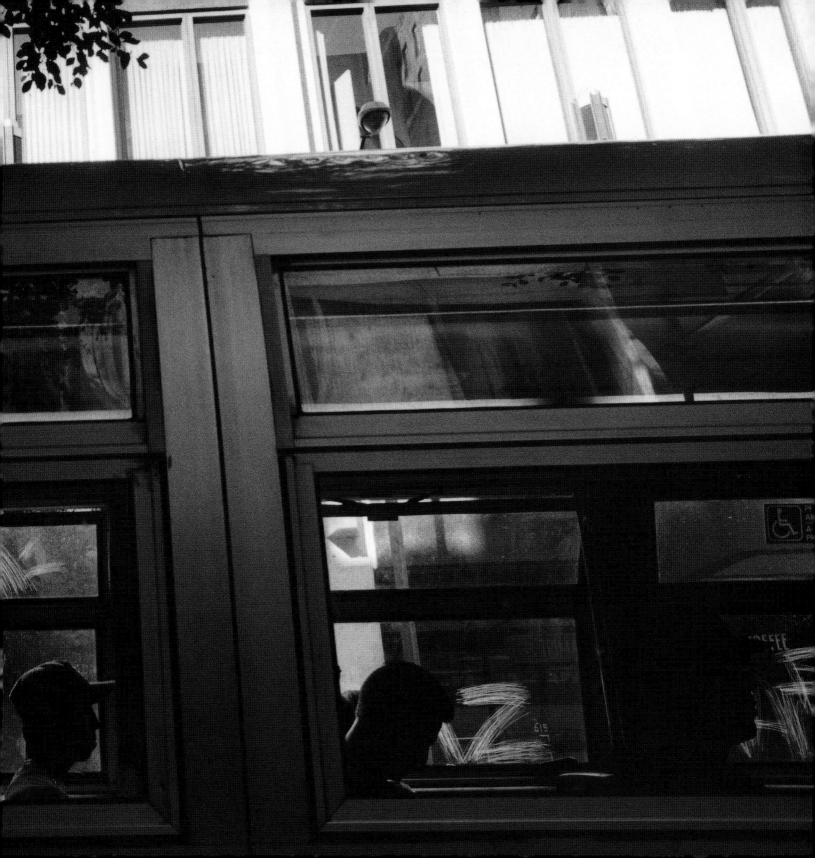

OR STAND IN FRONT of the Biltmore
Hotel on Pershing Square and look
down at the compass rose set in
the sidewalk that shows, against
the evidence of your eyes, that the
streets of downtown still resist, after
more than one hundred fifty years,
the city's American occupation
in 1847.

DOWNTOWN'S STREETS conform, as
best they can, to the orders of
Charles III, King of Spain. His
ordinances in the Law of the Indies
required the city grid to have a
45-degree disorientation from true
north and south to give, it was said,
equal light to every house through-
out the day. Given the way the
city extended along the bank of
its uncertain river, only 36 degrees
of compliance to the royal order
were possible.

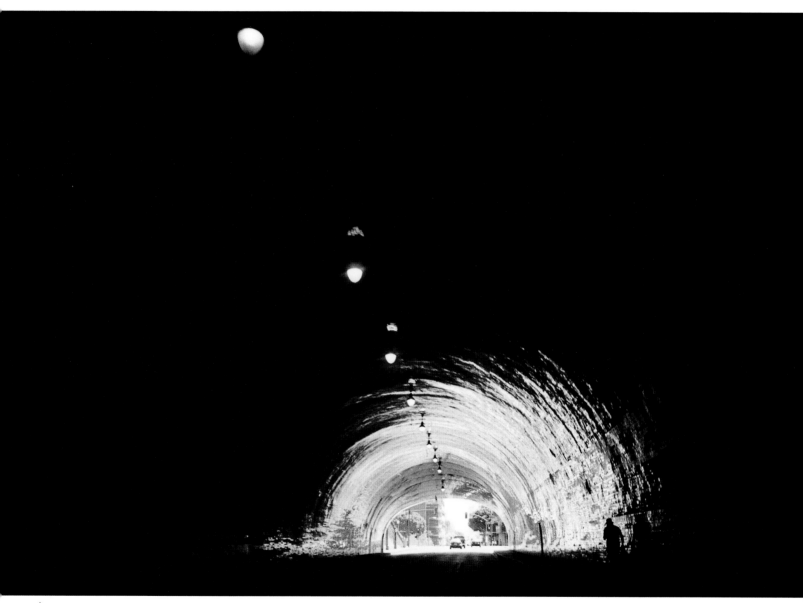

[Driving southeast through the 2nd Street tunnel

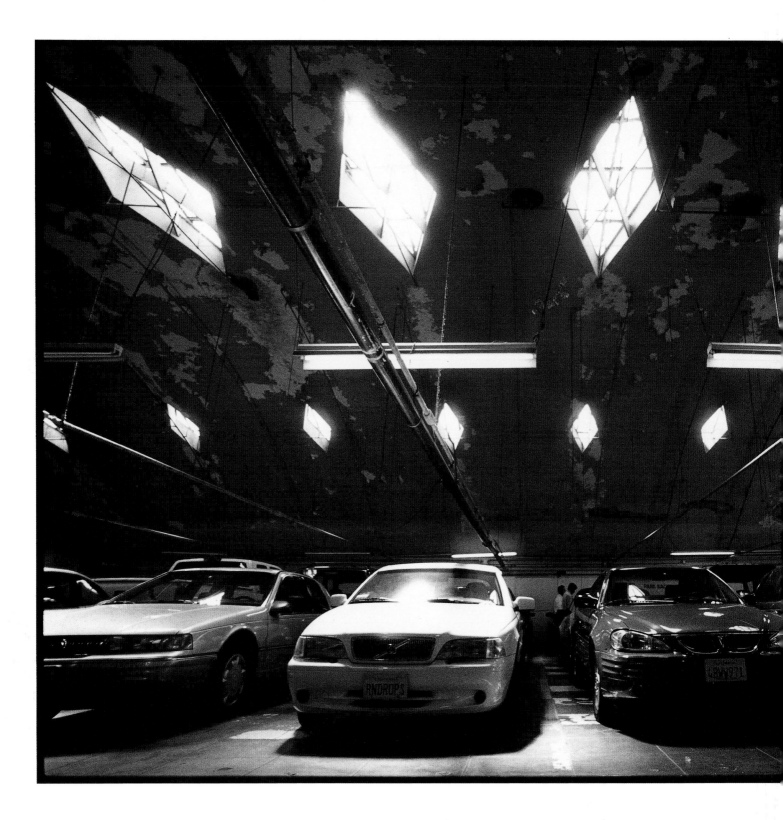

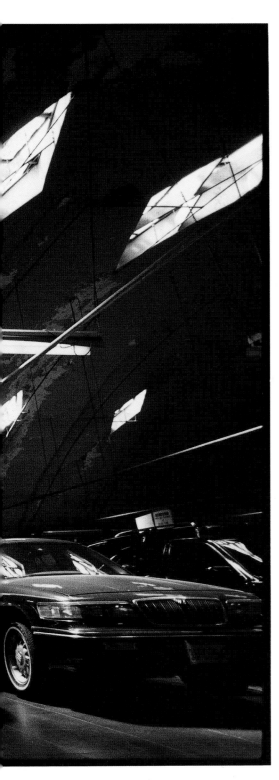

OTHER, MORE complicated allegiances claim those who cross downtown's misdirected thorough-fares today. They almost never note the grid over which they travel except, perhaps, as they reorient themselves to the Jeffersonian scheme beyond the boundaries of the colonial city, passing from one imperial imagination to another.

IN A DOWNTOWN that hopes to forget, the streets themselves remember.

●–●–●

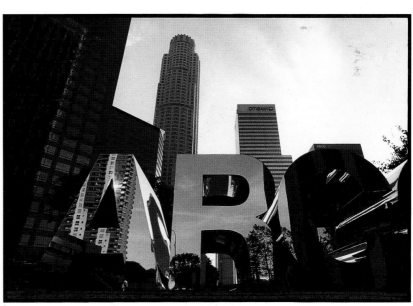

{ ARCO Center Logo on Hope Street

{ Diamond light in a Figueroa Street parking garage

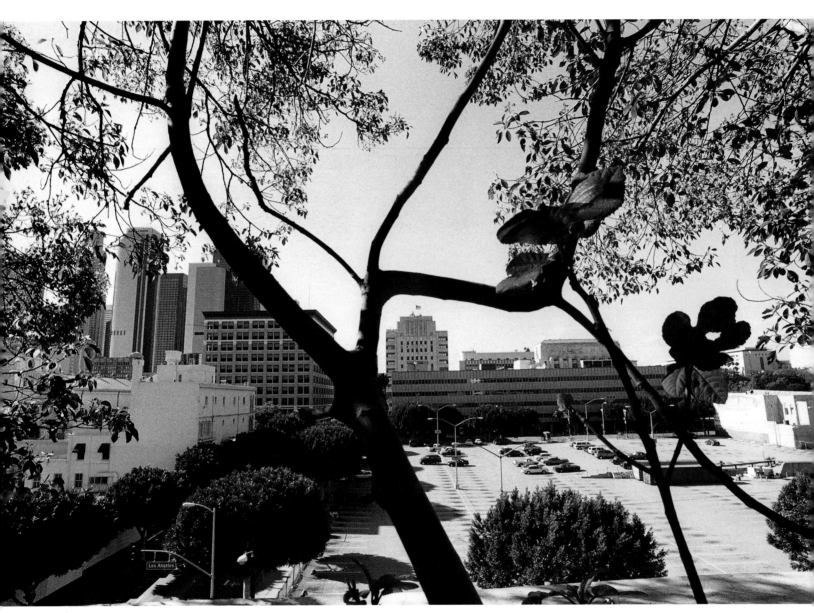

[Looking northwest from the roof garden at the New Otani Hotel

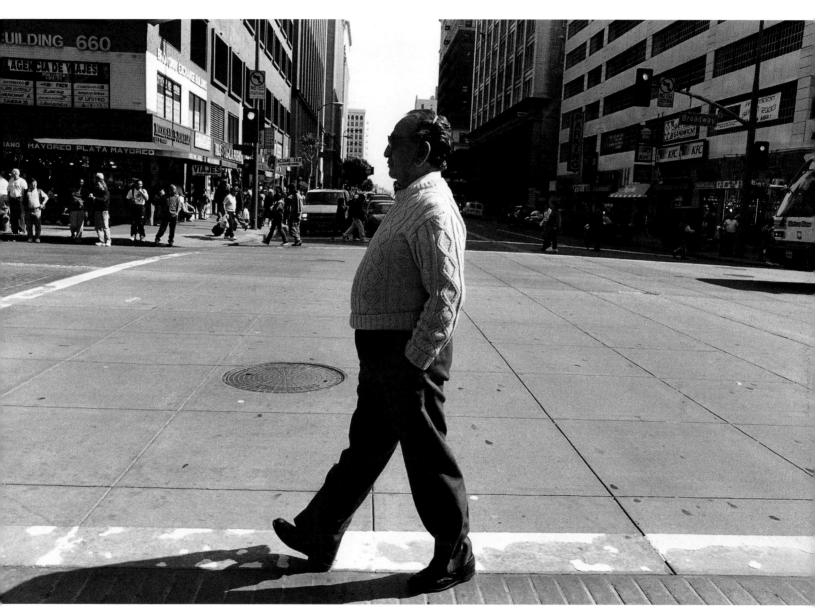

Crossing the street at 7th and Broadway in the jewelry district

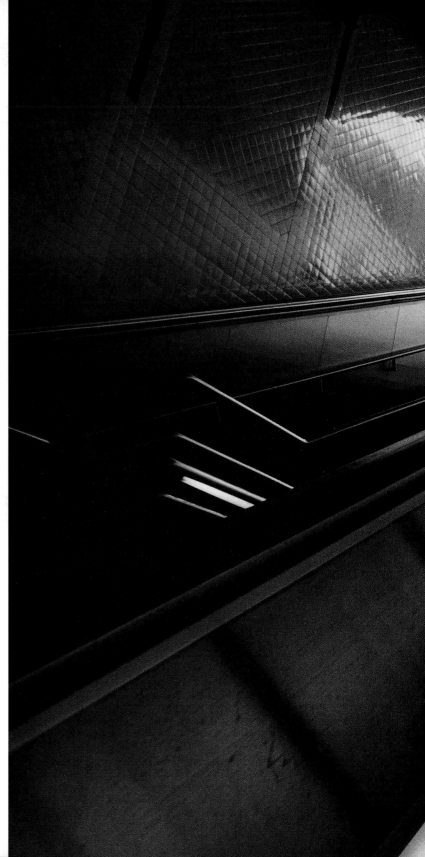

The Regime of Speed

IF YOU COULD SEE
the terraforming of
downtown at L.A.'s preferred pace—
at the speed of a fever dream—
the narrow shelf of land along the
river and the bluff behind it would
appear to shudder and struggle like
the body of a restless sleeper.

WHOLE HILLS
would twitch and be
gone for redevelopment projects.
New arroyos for freeways would
open between the knobs on which
the city climbed to escape its
Mexican memories. The course
of downtown's defining river would
seem to swing from the south to
the west and south again like the
pendulum of a titanic clock.

Approaching daylight at the Civic Center subway station

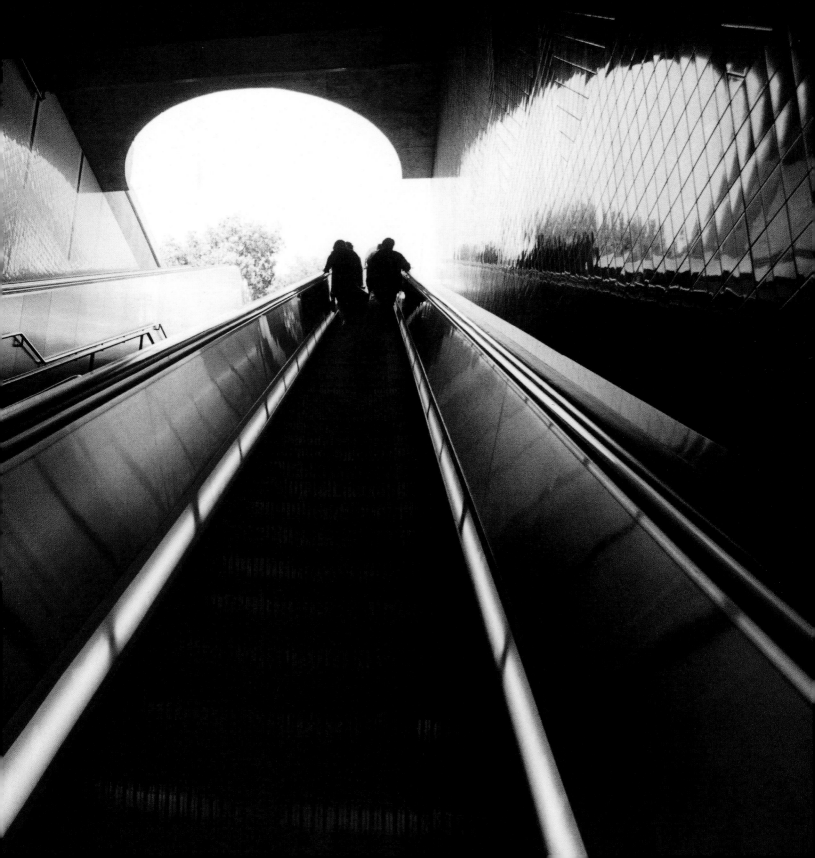

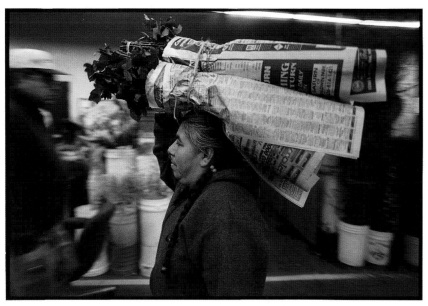

[Early morning at a Wall Street flower market

DOWNTOWN ITSELF would make a
two-hundred-year waltz along
the river bank, down into the flood
plain (near the present Union Station),
up the bank to the old plaza at
Olvera Street, and higher still as
the city center spread south along
Broadway and Spring Street and
northwest down First Street before
evaporating into the centerless,
everywhere-is-downtown of
the end of the twentieth century.

[Mid-day view of the Music Center's Walt Disney Concert Hall construction site

[Overleaf: Waiting for the bus on Hope Street near 1st Street

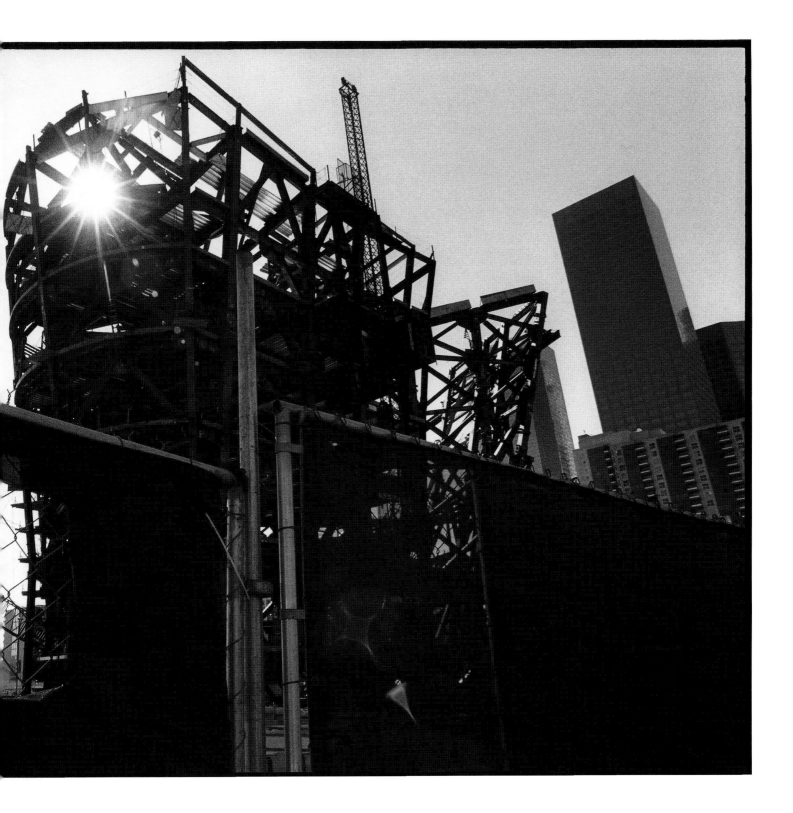

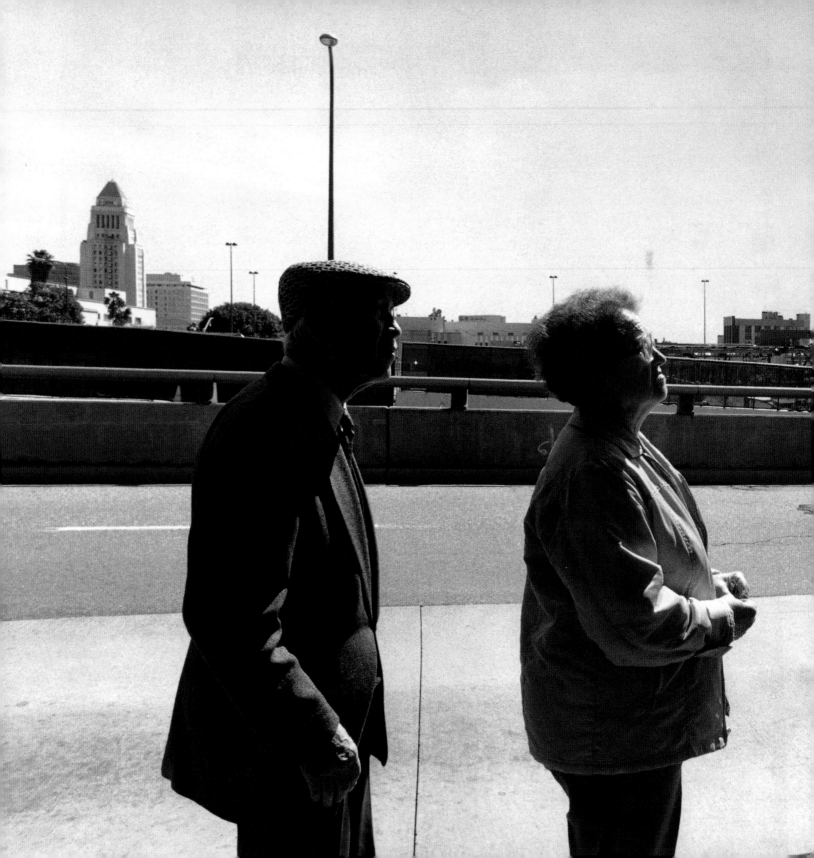

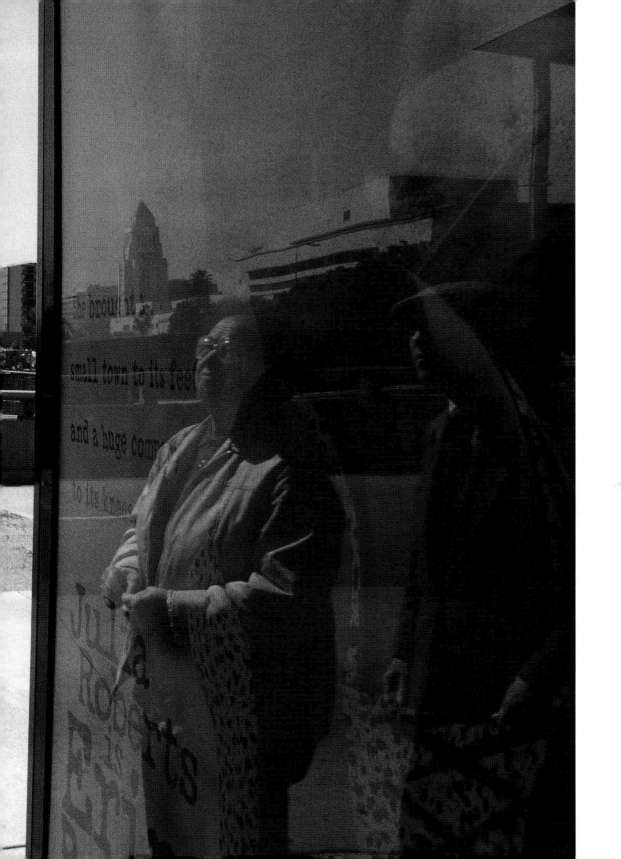

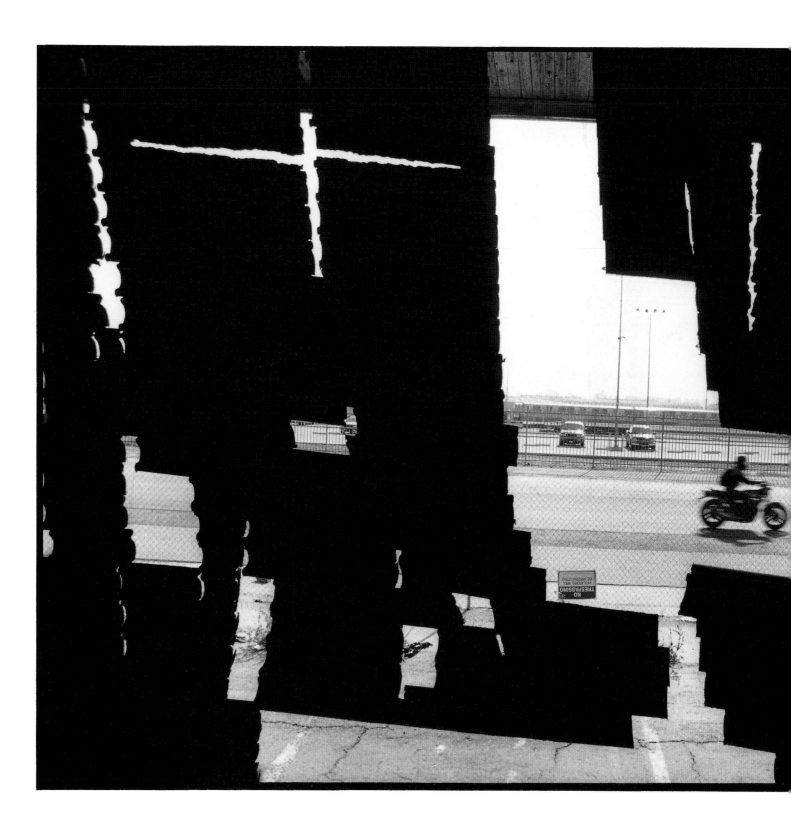

SPEED IS THIS CITY'S medicine for its anxieties about the permanence of palm trees, sunshine, and radical self-reinvention—the snake oil that downtown still cynically manufactures and naïvely buys. It's a sales pitch of seductive power and, sometimes, almost all there is of Los Angeles.

SPEED ISN'T ALWAYS that careless, however. Unlike some other big cities, L.A.'s successive downtowns barely overlap, so quick were they to be on their way to the next utopia. In our forgiving climate, a lot of our past hangs around, mostly empty and growing more dusty, but still available for rehabitation.

[Looking inside-out from an abandoned building on Santa Fe Avenue

A FORMER BUS GARAGE in Little Tokyo
is a temporarily permanent public
art gallery. St. Vibiana, the nimble
virgin, put her cathedral up for sale
and musicians are planning to
move in. A block of unused bank
buildings on Spring Street from the
1920s is becoming home to hurrying
dot-com workers. Disused ware-
houses will be housing students for
the Southern California Institute
of Architecture.

THE CENTER OF A PLACE without a
center is shifting north and east again.
Downtown is getting restless again.

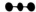

{ View along Temple Street of the early construction stage of the cathedral, Our Lady of Angels

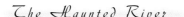

The Haunted River

THERE ONCE WAS A MESTIZA who was treated cruelly by her fair-skinned husband. He abandoned her and his two children for another woman who was not so dark. Mad with grief and shame, the mestiza flung her children in a flooded arroyo and then herself. She became a ghost. Now, she haunts dry creek beds and open ditches.

THE GHOST of the woman lures careless children who are playing there in the rain and drowns them in the suddenly rising water. If you are unlucky, you'll see her in the muddy wave rushing at you as fast as a speeding car, her gray gown curling at her feet and her white rebozo thrown over the weeping sockets in her *calavera* face.

[Watching the Metrolink train near the 1st Street bridge

SHE IS LA LLORONA, the Woman Who
Cries. After a relatively light rain
in late November 1998, just before
the school day began, she took
seven teens loitering in the channel,
dragged them into the brush that
pokes up in places, and drowned
three of them.

THE COUNTY school board circulates
a video and educational guide
called *No Way Out* to explain the
hazards of the rain-swollen river:
the algae-slick floor of the channel,
the quick hypothermia of 50-degree
water, and the impossibility of finding
a place to hold on in a current
flowing at 45 miles an hour.

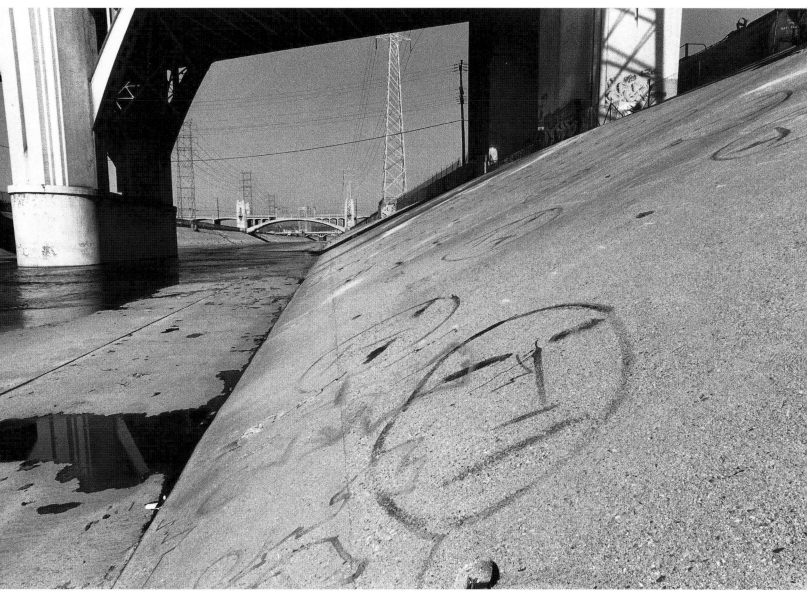

The face of the Los Angeles River under the 6th Street bridge

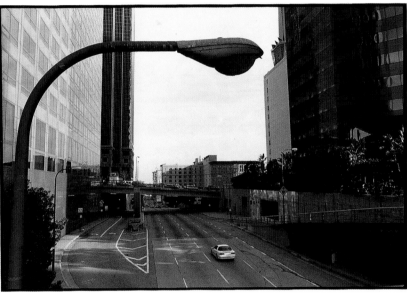

[Late afternoon, looking southeast over 4th Street

[Filming a commercial on 6th Street near Olive Street

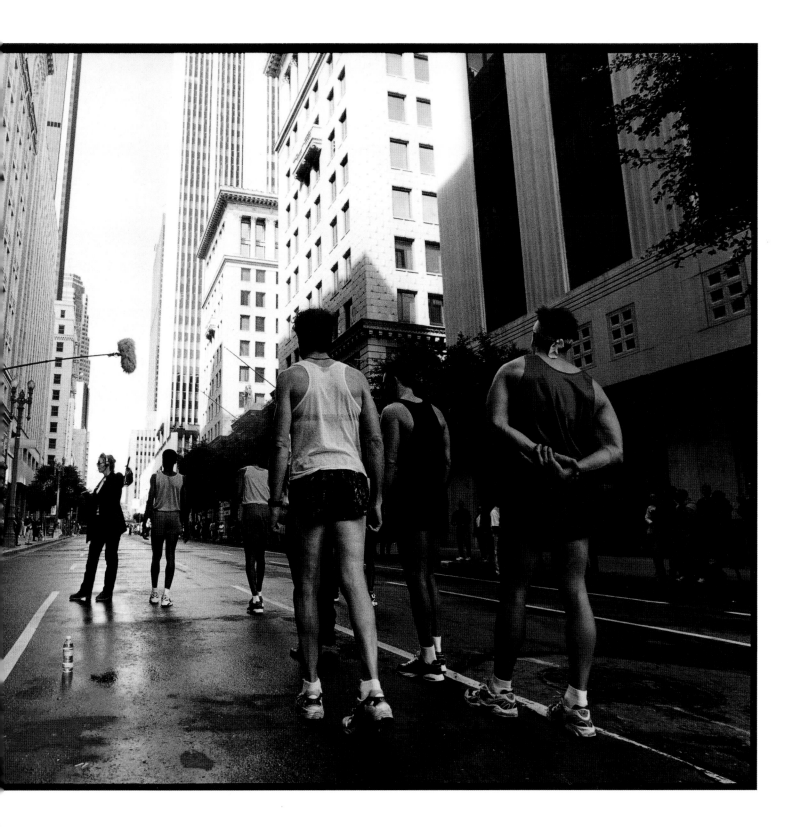

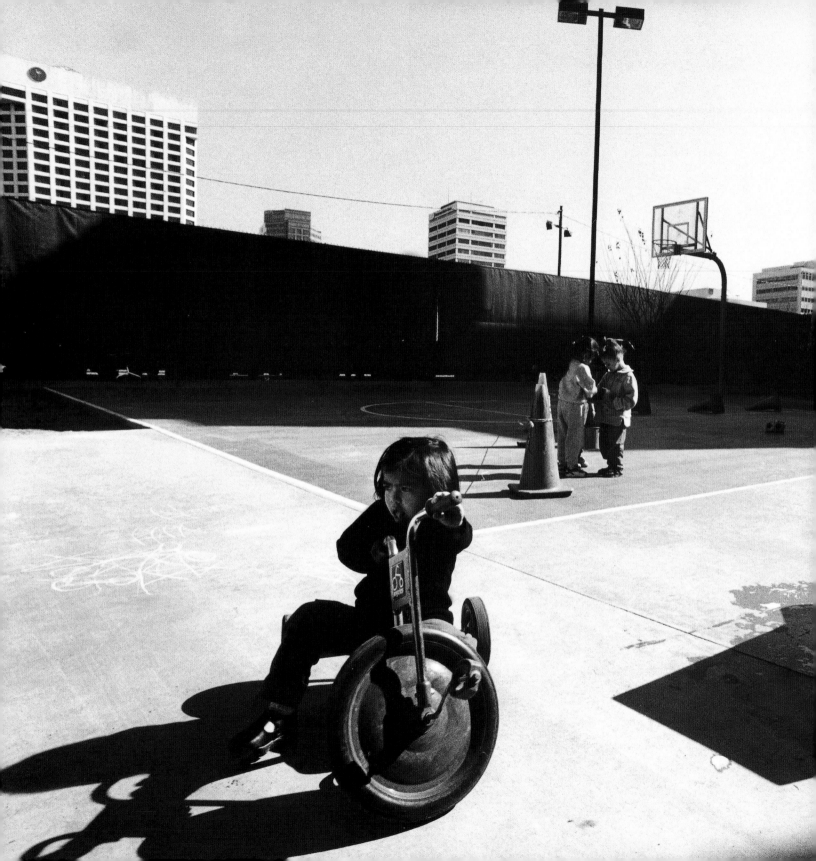

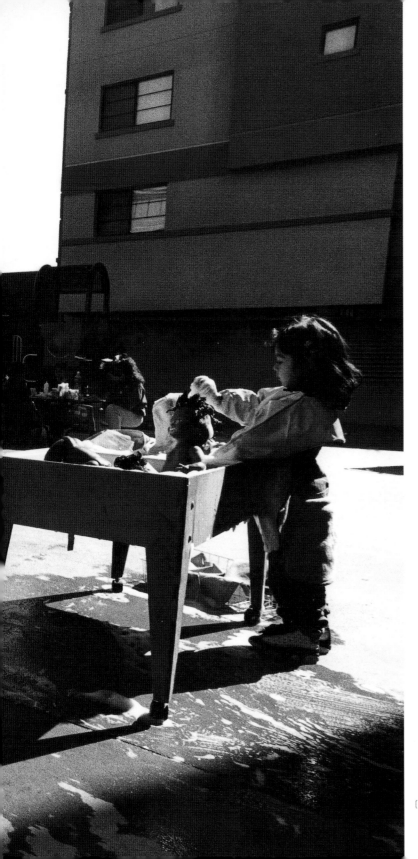

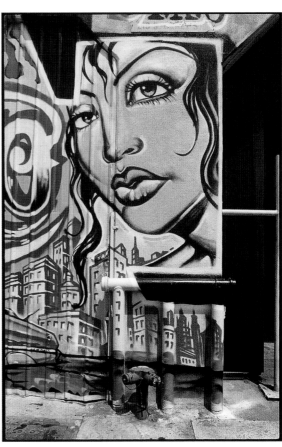

[Commissioned graffiti art on a warehouse wall on Garey Street

[Business as usual at the Grace Iino Preschool on 3rd Street

37

LA LLORONA is the custodian of the placeless, concrete void we've made in our image on the eastern edge of downtown. She was first evoked by the city's indifference to its unsatisfactory river as the city grew west and north. She grew on the city's memories of flooding after the river channel was paved and straightened. She still accompanies the graffiti artists under the Sixth Street bridge, takes the homeless, and provides a warning to the children of *indio* mothers illegally laundering in the water of the shallow slotflow that marks the center of the channel on every day without rain.

WHEN I LOOK into the glare of the empty river from a bridge parapet on a hot August afternoon, six months since the last rain, the concrete below is a burning mirror reflecting our contempt for what we've done. And La Llorona stirs.

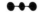

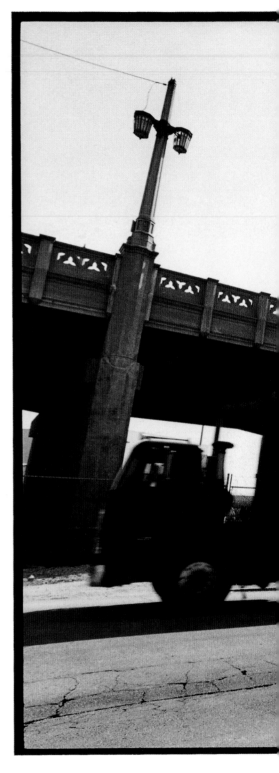

[Intersecting views from under the 3rd Street bridge

[Overleaf: Jung Shim in the seniors swimming class at the Ketchum Downtown YMCA

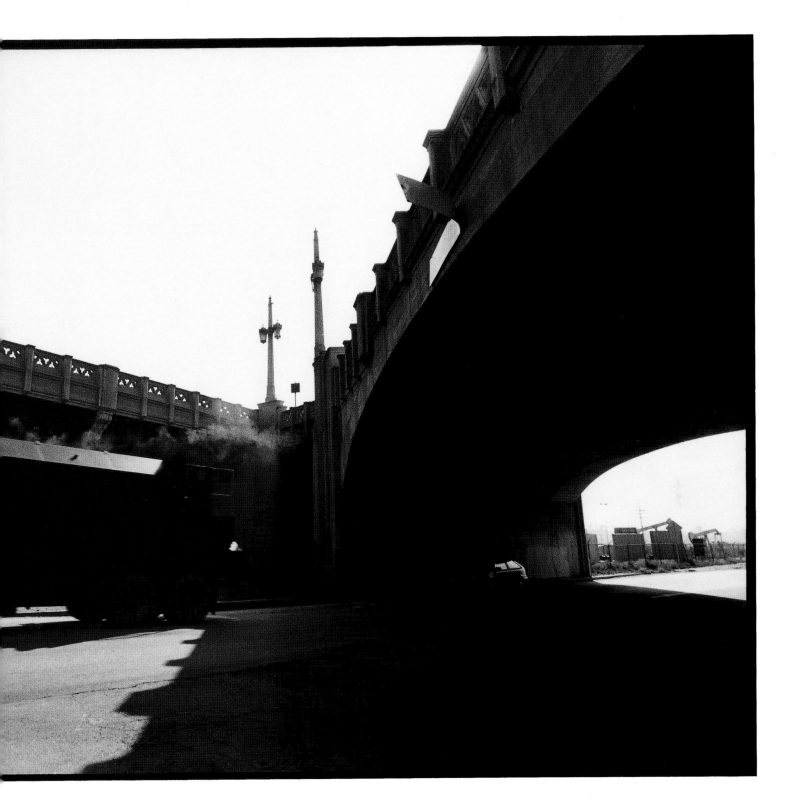

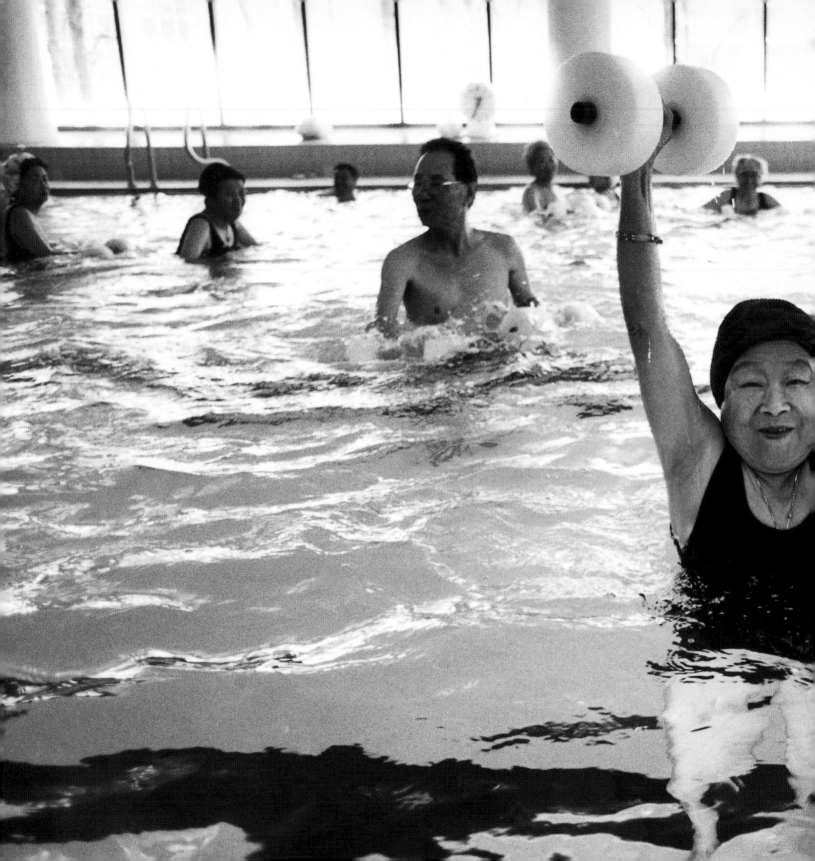

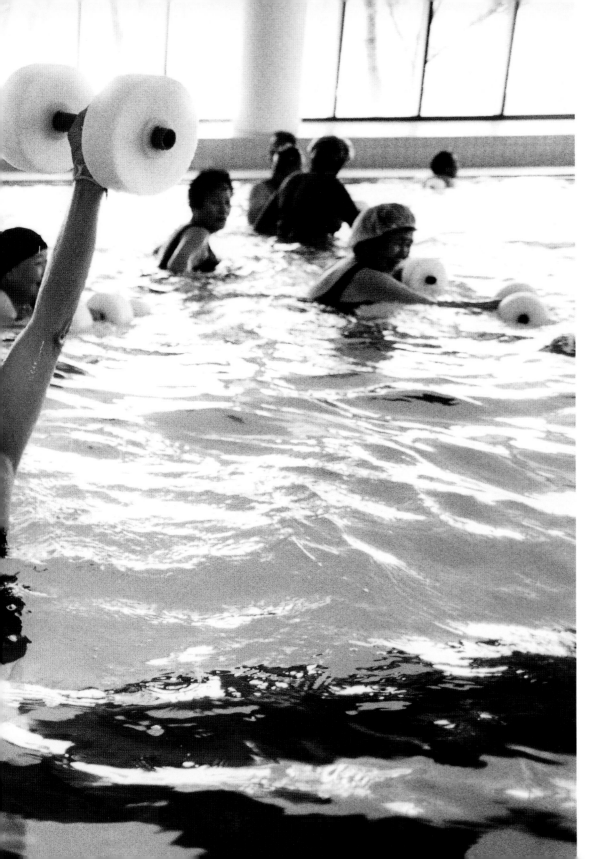

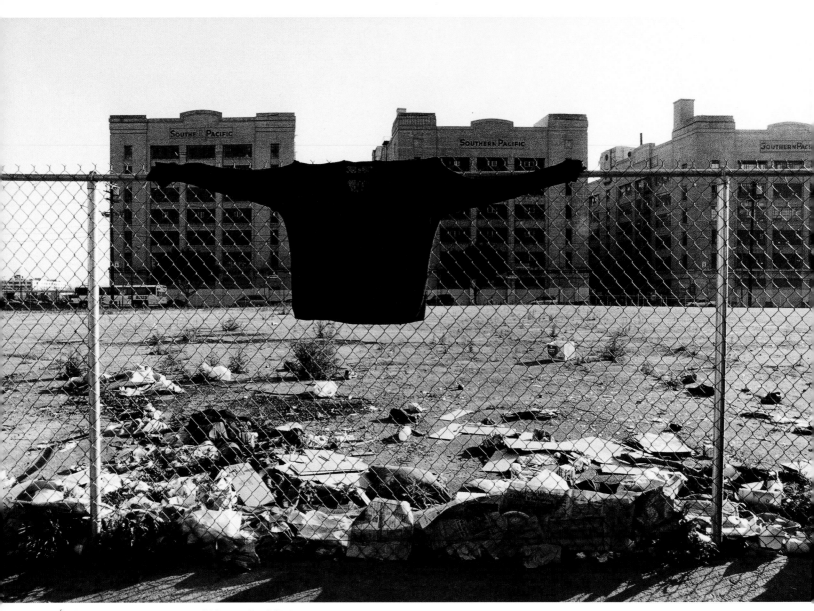

[Drying sweater near a homeless encampment on 7th Street near Alameda Street

Marooned

LOS ANGELES IS AN ISLAND
on the land,
as Carey McWilliams, its greatest
chronicler, famously reminded us.
Downtown is doubly moated: an
island within an island. It's even
more an island of the mind than
an island on a map.

IT'S THE UNQUIET
center from
which Anglo Angelenos have fled,
except as a place to work, since
the booms of the 1870s and 1880s
turned a sleepy cow town into a
passable imitation of a Midwestern
county seat.

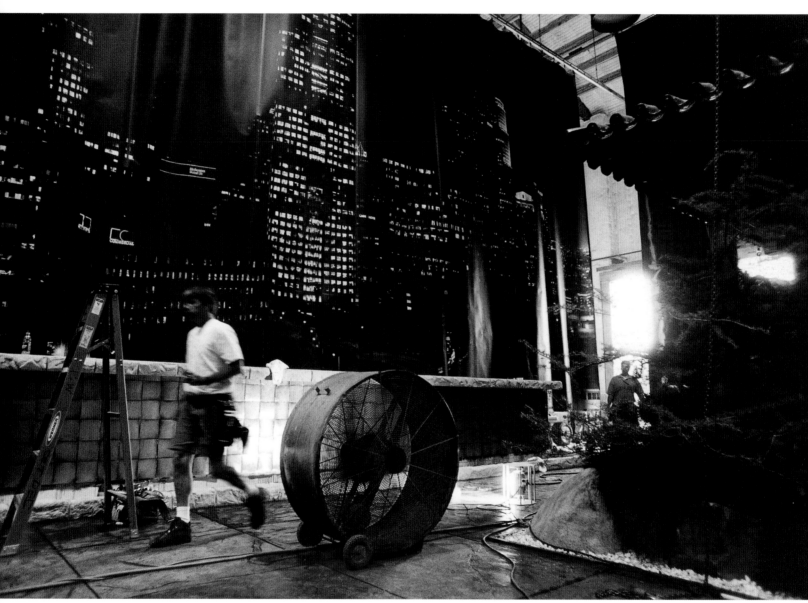

[Creating a downtown night on a film set at the Los Angeles Center Studios located between Beaudry Avenue and Bixel Street

Opening night crowd views "100 Years of Architecture" exhibition, at the Geffen Contemporary, Museum of Contemporary Art

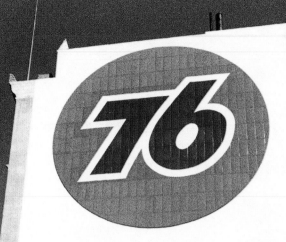

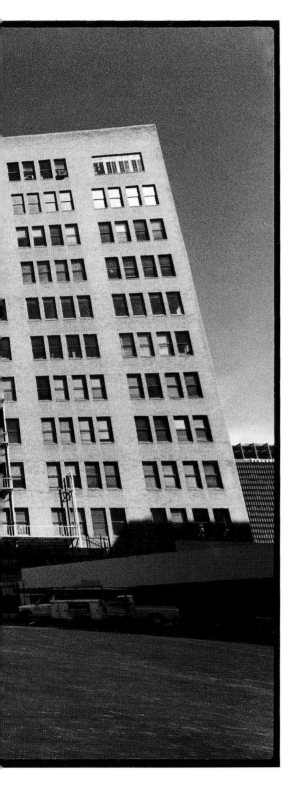

IT WAS NEVER very urban, except as a patch of brick, dressed stone, and terra-cotta office buildings in the financial district along Spring Street. Even when downtown became more like a "real" downtown of tall corporate buildings and substantial government offices, the complaints were loudest that this downtown had erased a better and lovelier city.

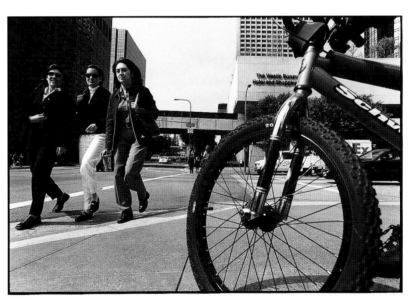

[Leaving lunch at 5th and Flower Streets

[Beautifying the landscape at the intersection of Olympic Boulevard and Figueroa Street

LOS ANGELES LIVES with the contradiction that fuels this unease. Every effort to make another "perfect place" out of L.A. disrupts the longed-for qualities of the last perfect place that had been built on the remains of the previous one.

THE LATEST DOWNTOWNS are just as contradictory. Dot-coms and telecom companies fill one block of sober bank buildings, mostly unused since the 1970s. New urban pioneers take lofts in an identical row of empty office buildings nearby. The gargoyles, Classical nymphs, and Baroque *putti* that watched over eighty years of other "perfect places" watch over these contentious new ones.

THE DOWNTOWN OF LOFTS and the downtown of dot-coms are equally self-invented; both depend on memory's lack of substance here.

[Deputy Police Chief David J. Gascon, gets a trim from barber Duane Shields, at Pacific Center Barbers on 6th Street

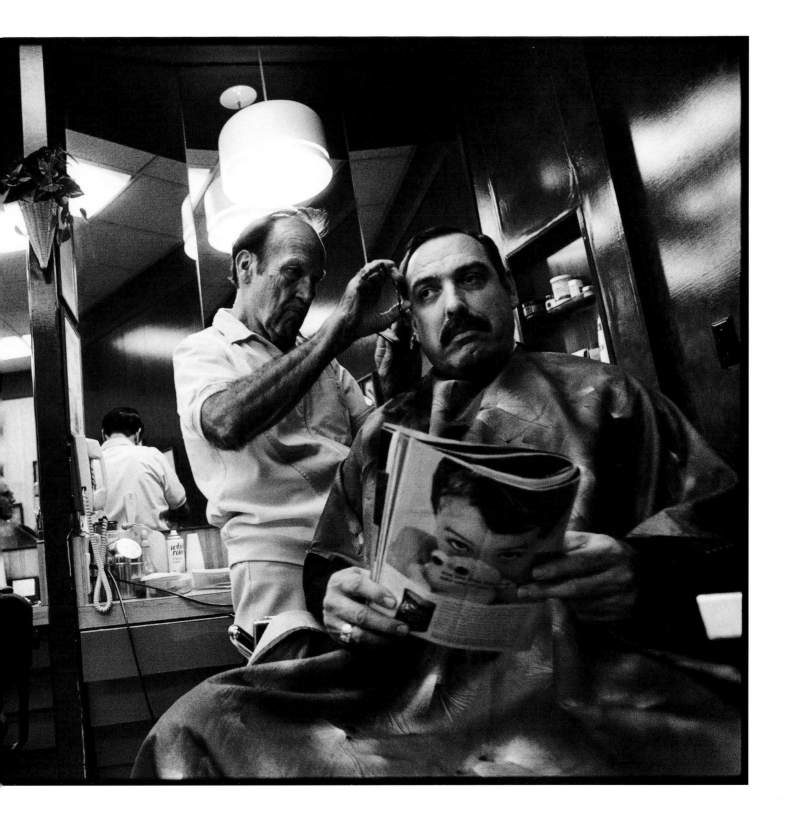

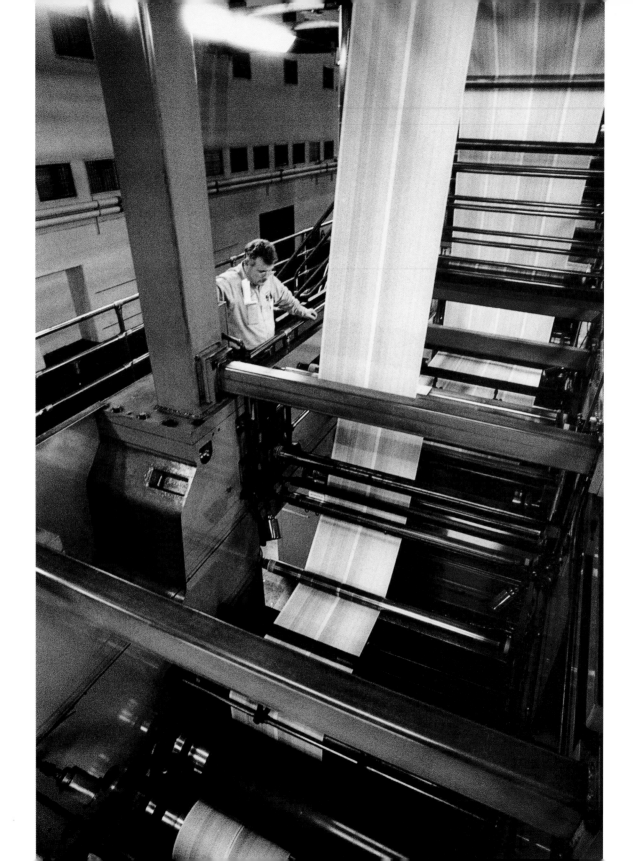

"MANY RESIDENTS SAY that part of what is so interesting about this new experiment in urban living is the learning curve, making up the rules and learning as they go," noted a story not long ago in a downtown newspaper. From the discarded and partially erased materials of its former selves, every downtown has made itself up.

●·●·●

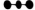

[Printing the newspaper at the *Los Angeles Times* facility near Olympic Boulevard

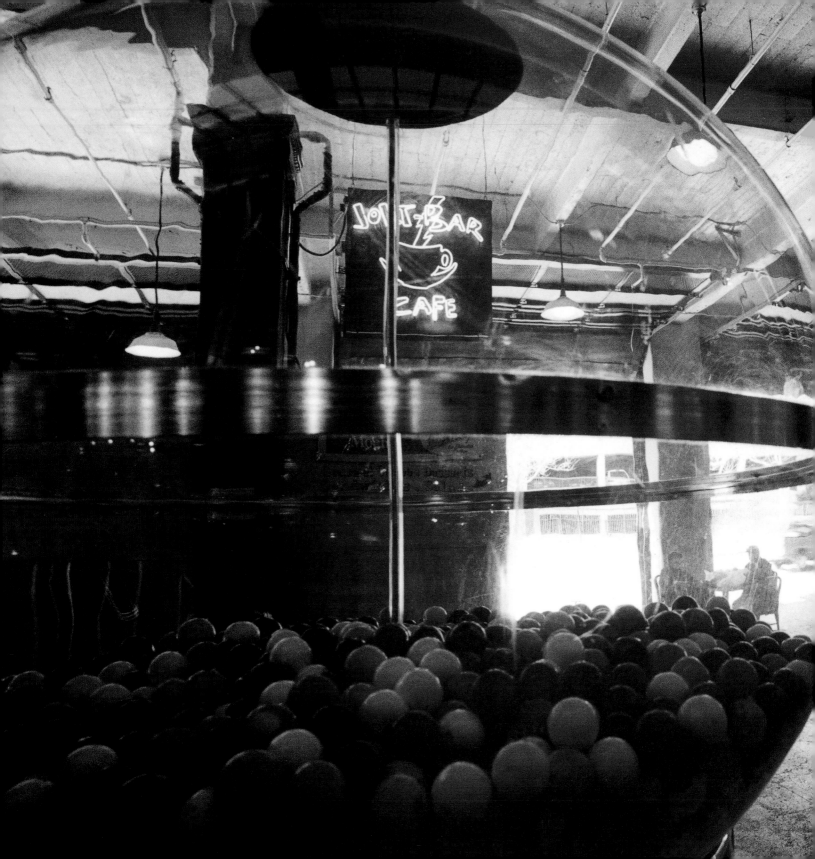

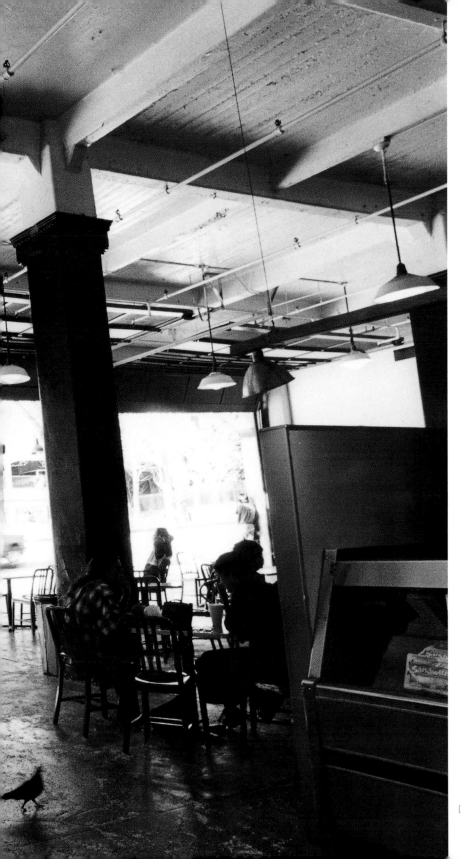

The world in a gum-ball machine at the Grand Central Market on the Hill Street side

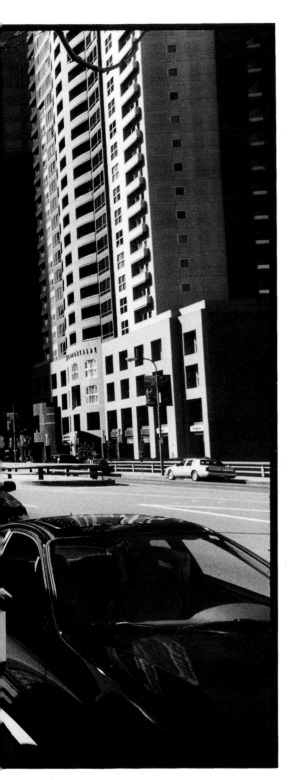

THERE ARE TWO DOWNTOWNS.

One rides.

The other walks.

THE DOWNTOWN that rides gets tangled in the city's overlay of nineteenth- and twentieth-century streets. It gets frustrated by their unexpected one-way divisions. Tall buildings block the horizon that Angelenos see as the backdrop to their life on wheels. You have to pay too much attention downtown. The freeway, with its promise of release, feels too far away.

WHAT MAKES downtown frustrating to drive makes it memorable to walk. Downtown has the human-scale vistas framed by the patterned facades of mostly mid-rise office

[A solitary stroll on a Saturday afternoon near the Museum of Contemporary Art at California Plaza

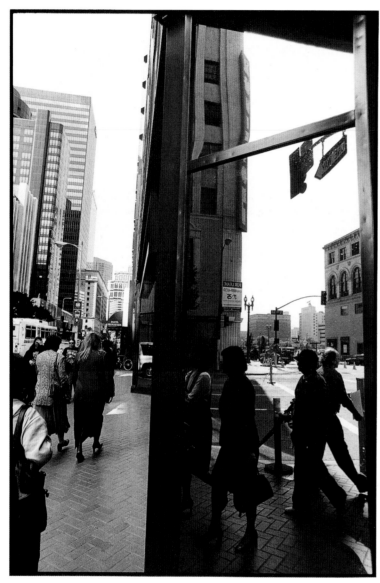

buildings. It has the interesting tension between the architectural order above your head and the relative disorder of the sidewalk around you. It can't be displaced by playing a CD or tuning to talk radio. Downtown has smells and textures. The buildings themselves invite your inspection. They want your appraising look, which is only possible at a walker's pace.

THE DOWNTOWN that walks resists the concealing skin of automotive steel and glass that we wear on the road. Down among the pedestrians, the gazes are more direct. What we give and get on foot is regard.

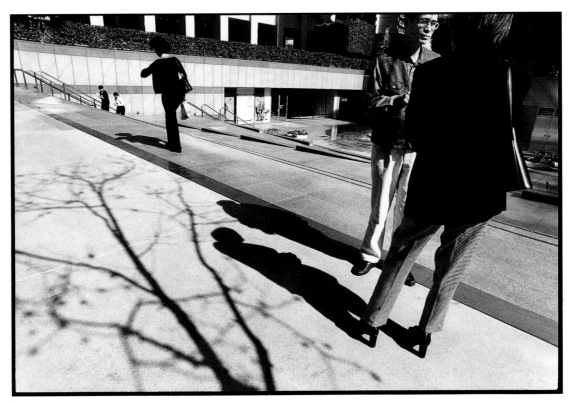

[Winter light on Grand Street at California Plaza

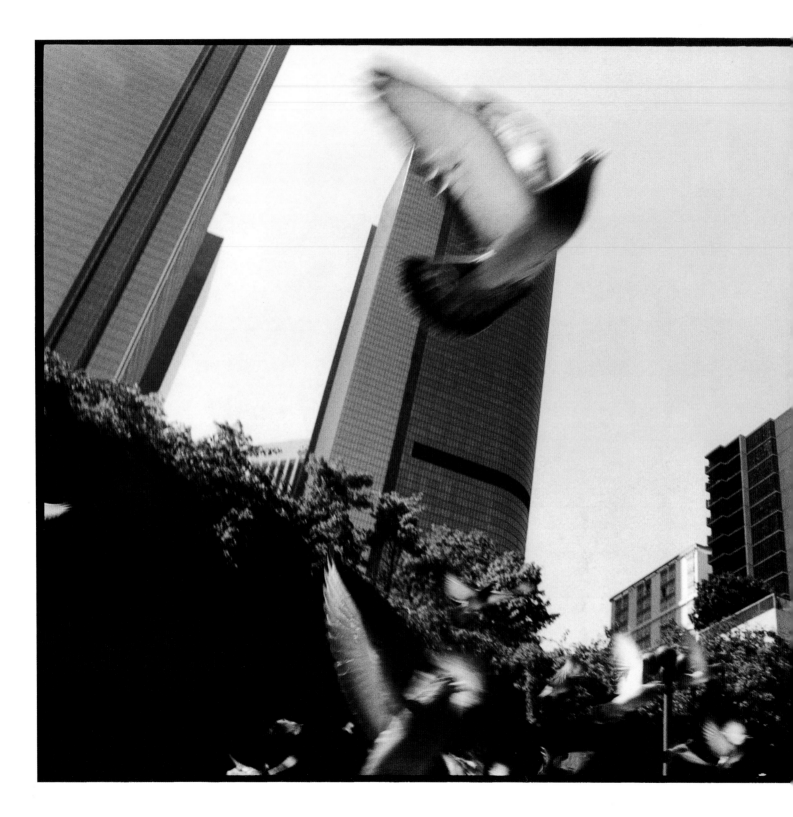

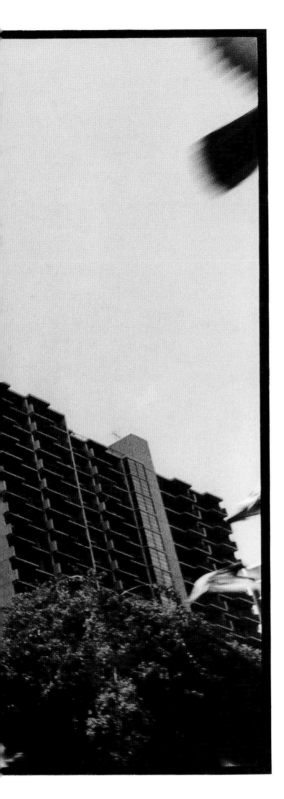

A School for Urbanity

BENEATH THE UNSETTLED SURFACE of downtown is another system where, every few minutes since 1993, a secular community assembles, interacts, and disappears. Its members gather, still a little amazed at times, as L.A.'s new subway riders.

THE SUBWAY they wait for isn't much by metropolitan standards. It won't ever condense the city the way the subway in New York does. L.A.'s subway isn't even much good for getting around the city, but it's very good for getting around the city's preference for missed connections.

[The face of Bunker Hill from Hill Street, skyscrapers and senior housing

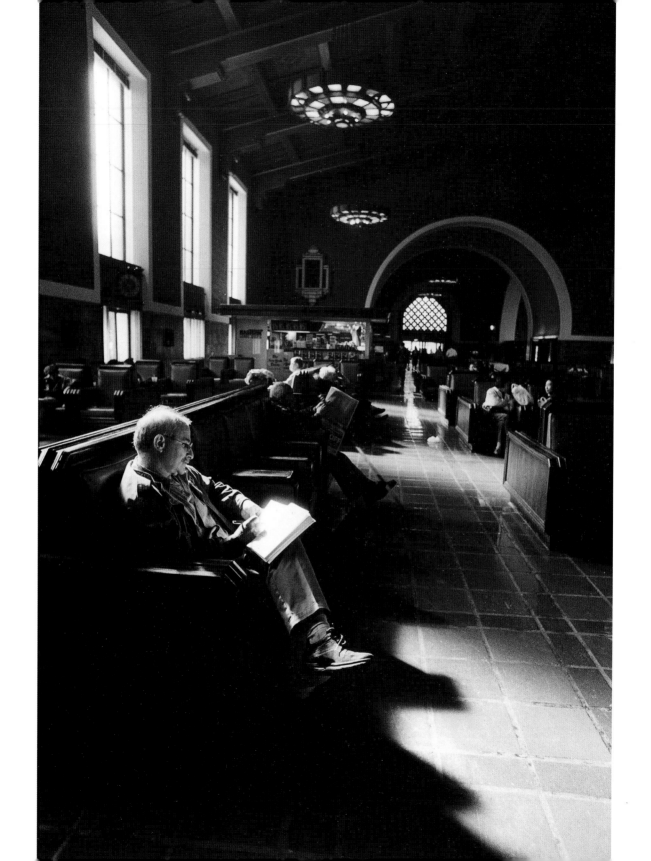

THE WAITING RIDERS below Pershing
Square have the freshness of recent
converts, but also their tentative
ways. In notoriously private L.A.,
most Angelenos haven't acquired
the habits of being in public, as
they must be downtown. The riders'
uncertainty shows as they disperse
themselves in the cool, even light of
the subway platform. Their quiet is
a little churchly. The arriving train
announces itself with a slight breeze
pushed by the lead car and then with
a high, electric whine as the subway
train brakes. For a moment, as you
almost never do in L.A., you nearly rub
shoulders in the clot of passengers
leaving and entering the car.

THE RIDERS FIND seats, settle into
themselves, and are carried away.
You can see in their glances, though,
that they are learning to pay attention
to each other. They are learning
one of the key lessons of city life.
They are learning how to be thrown
together into a peaceable assembly
momentarily unsorted by race and
income the way the rest of L.A. is.

[Reading and writing in the lobby of Union Station

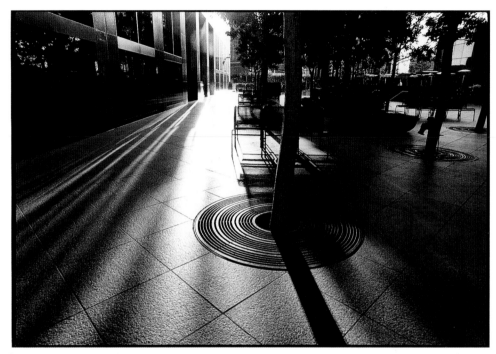

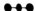 Saturday sunlight setting in Wells Fargo Plaza off Hope Street

THOSE WHO WAIT are Ethiopian immigrants and Kansas tourists, suited government bureaucrats and tired janitors, pierced and tattooed street kids, and office workers with weary eyes. They've come, paradoxically, deep inside downtown only to become more outside themselves.

●-●-●

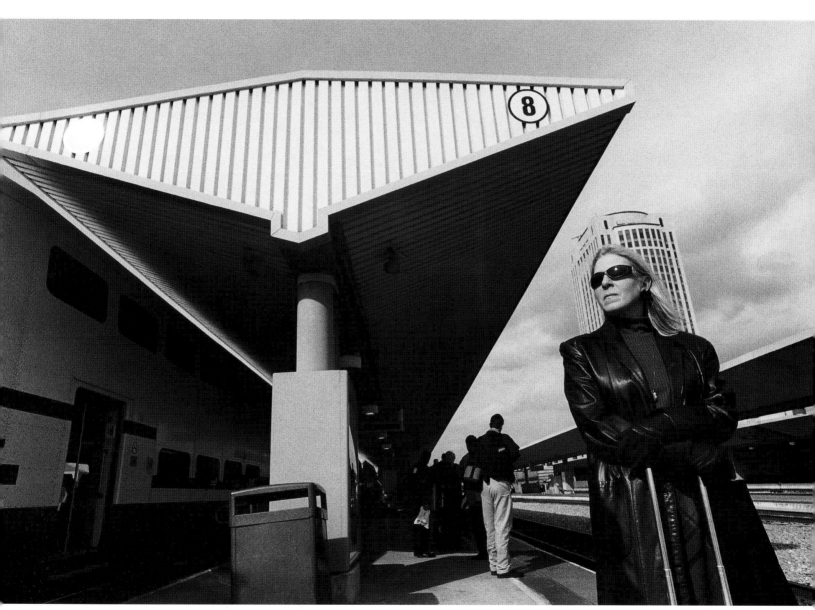

[Waiting for the Metrolink train at Union Station

Still Smaller Than Burbank

THE DOWNTOWN CENTER
Business Improvement
District predicts that downtown's
housing stock will reach more
than eighteen thousand units by
2004. Depending on your definitions
of "downtown," "housing unit," and
"resident," the center of the city
today has about twelve thousand
units and about twenty-five thousand
residents.

THAT'S AS MANY
people who lived
in Los Angeles in 1885, almost
the last time that downtown and
Los Angeles were the same place.

CITY PLANNERS
and the developers
would like to see a downtown
population of one hundred thousand.
That will probably mean more people
living in the center of the city
than have ever lived there before.

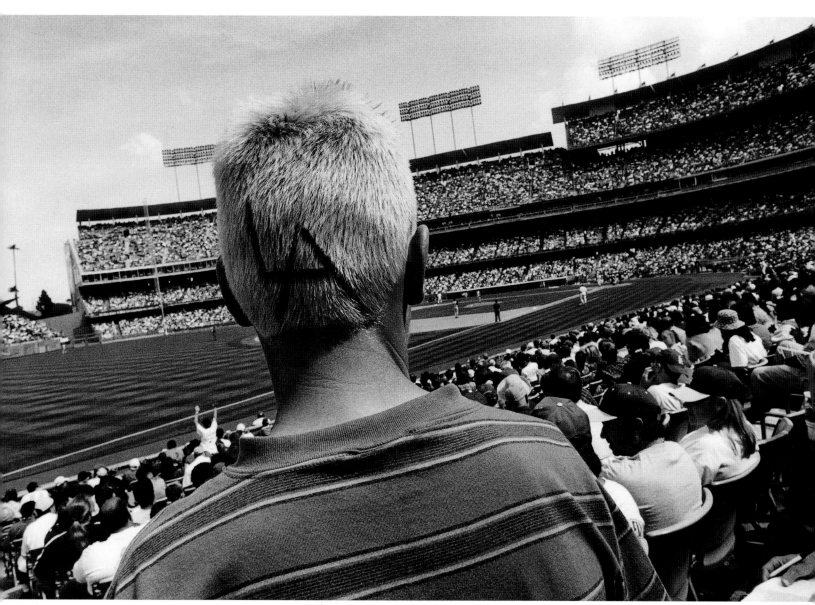

[Supporting for the home team at a Sunday afternoon Dodger game

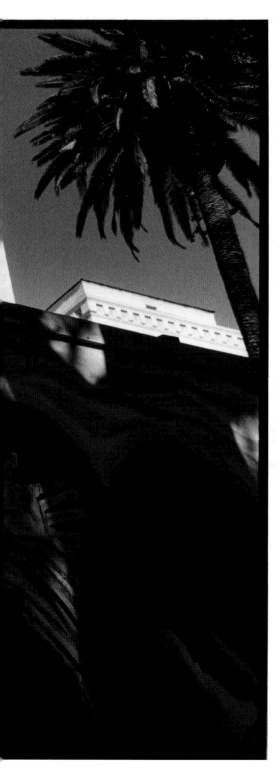

Downtown, if its population grows
and if it were unhitched
from L.A., would become a city
comparable in size to Carson and
Norwalk, though somewhat smaller
than El Monte or Burbank.

DOWNTOWN MAY ACHIEVE this goal.
The current residential boom began
to build in mid-1999, when the
city's "adaptive reuse ordinance"
gave building code exemptions
to developers converting old offices
into housing units and retail.
According to at least one estimate,
there are about two hundred
buildings available for adaptive
reuse downtown, with thirty million
square feet of space that could
be refilled with wayward,
American dreams.

DOWNTOWN'S DREAM is reinvention—
one day you're a *campesino* and
the next you're clearing dishes in
a downtown restaurant. One day
you're a restless suburban home-
owner and the next you're renting
a downtown loft. Something is
erased. Something else is inscribed
in its place.

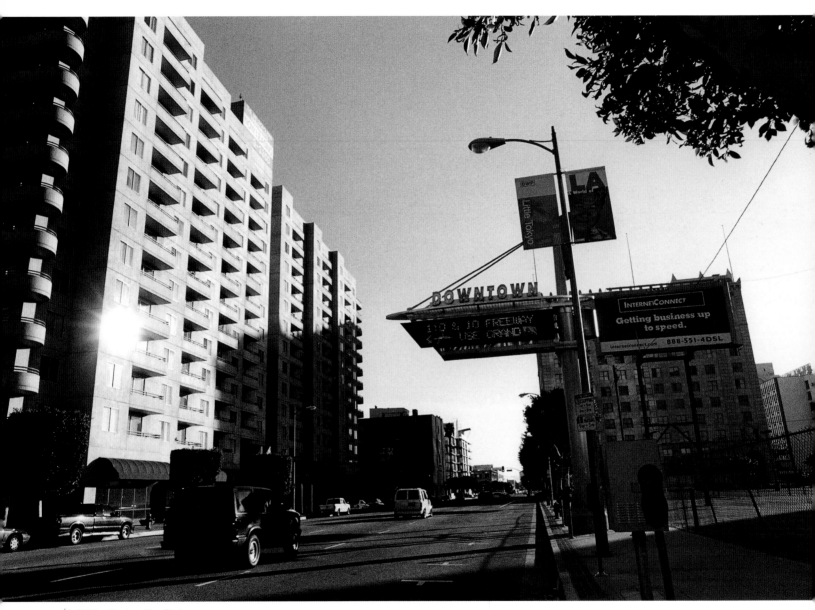

[Traffic information sign on Flower Street

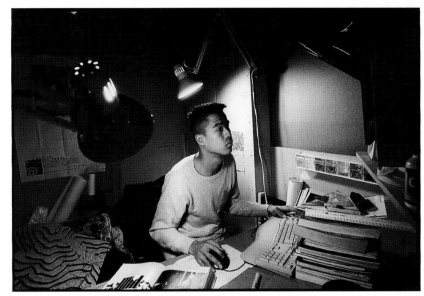
[Southern California Institute of Architecture student Shawn Leong focuses on his work

YOU SEE YOURSELF living here, but only as long as "here" is indeterminate. "When the Gap comes, we'll go," a recent loft move-in said.

WE WANT, unreasonably, American places that will transform each of us as America has transformed the whole of us.

WHAT WE NEED are habitats for memory where longing might be, if only briefly, assuaged.

●–●–●

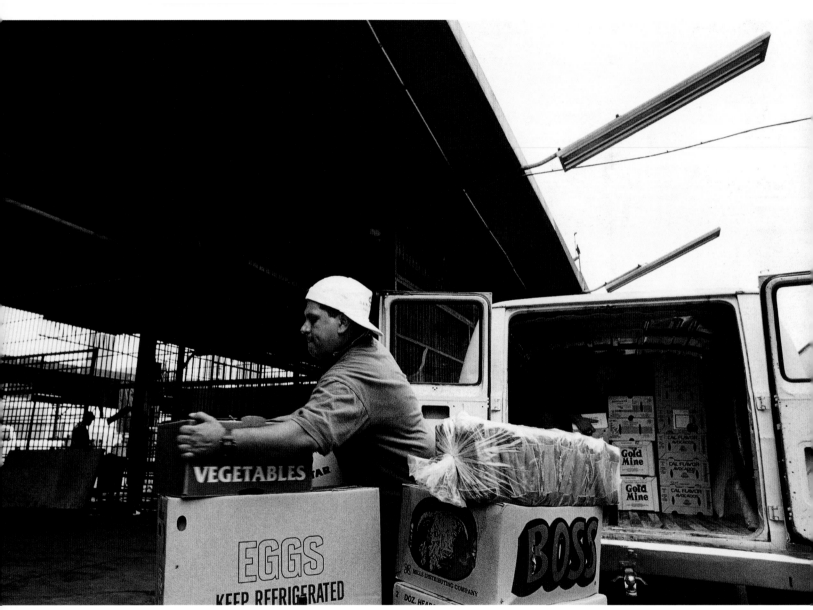

[Loading crates at the produce market on San Pedro Street

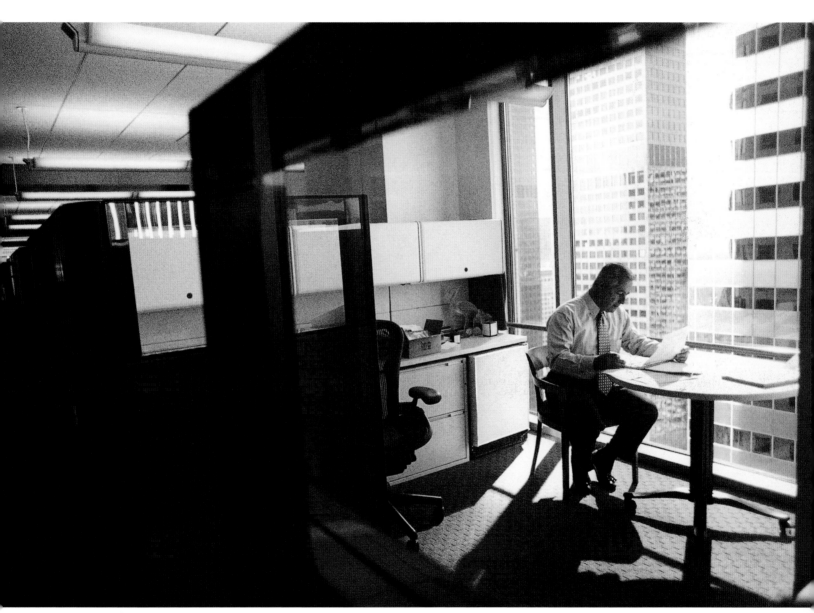

[Managing Partner Dick Poladian in his office workstation at Arthur Andersen on Bunker Hill

Iglesia de Nuestra Señora de Los Angeles

THE OLD CHURCH ACROSS from the plaza where Los Angeles began in 1781 isn't a place of sacred stillness. The church is open throughout the day for all kinds of visitors, and the little nave will often fill unexpectedly with the faithful in their devotions. On Saturdays and Sundays particularly— when crowds attending baptisms and weddings spill into the court- yard outside the north entrance— the Church of Our Lady of the Angels is a place of passionate noise.

MOTHERS AND FATHERS holding babies in stiff baptismal dresses line up alphabetically at the order of ushers in blazers with name badges. Young women in white dresses like brides laugh and then grow serious as they wait to be called into the church to receive the blessing that comes with their fifteenth birthday. Real brides—

[Guadalupe Xitlah Velasquez, 10, at home with her shrine to Our Lady of Guadalupe

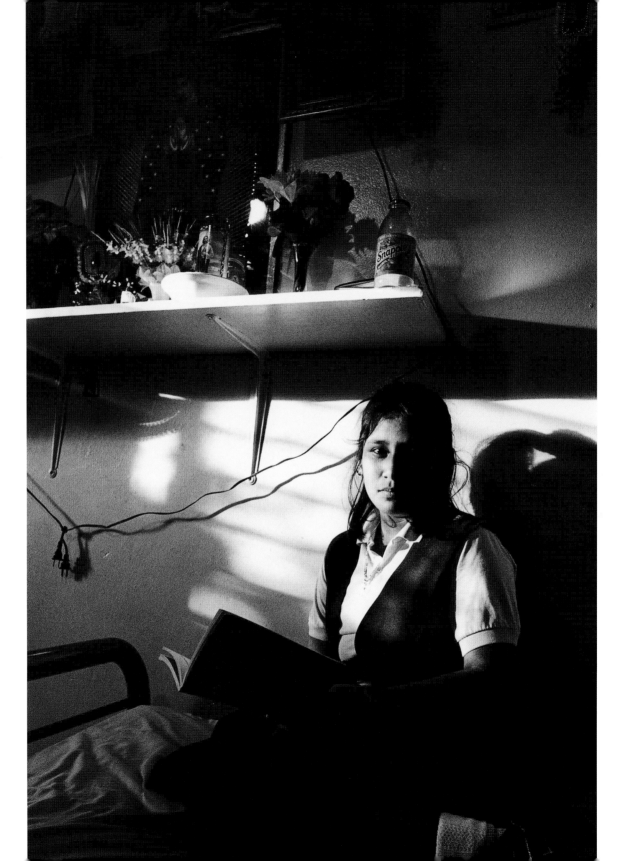

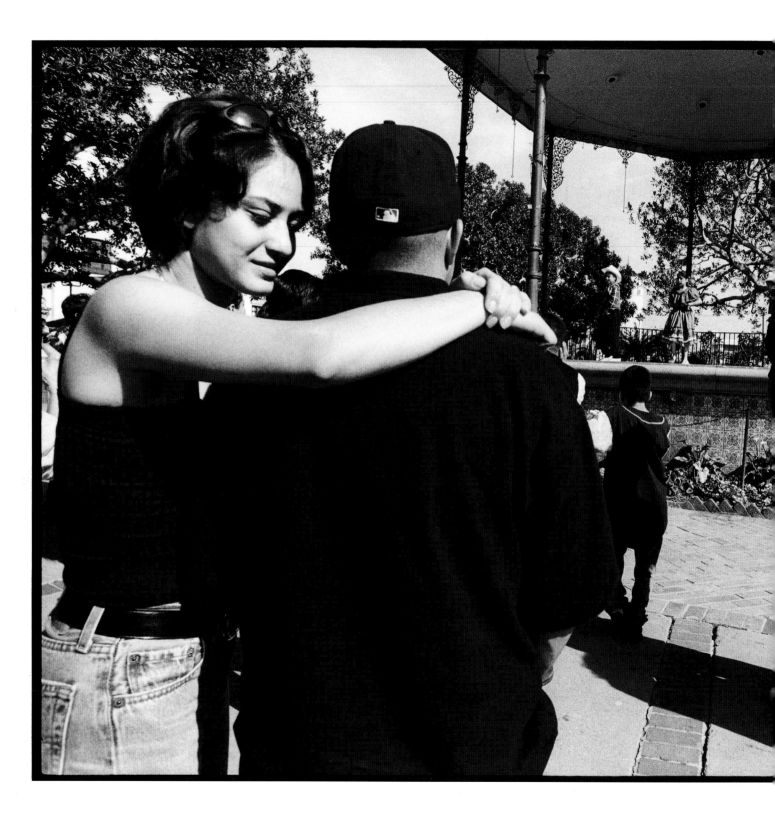

and grooms, bridesmaids, and groomsmen in relays—smile and have their pictures taken.

WHILE THEY WAIT in the sun, someone may hawk tickets to the parish raffle over a loudspeaker. There might be a band. Over them all hangs the pungent smoke of vendors outside the church doors grilling *tacos al carbon*.

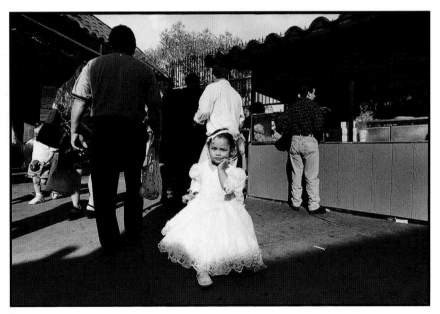

[After the christening near the Church of Our Lady of Perpetual Adoration on Main Street

[The Olvera Street bandstand on a Sunday afternoon

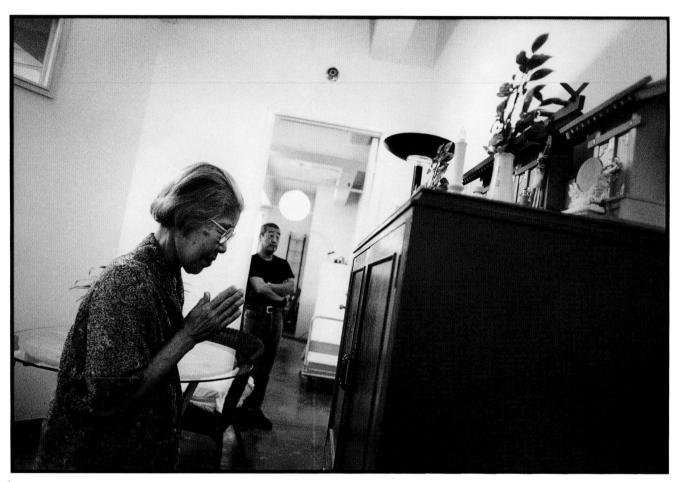

[Yuriko Kamata prays at a Shinto shrine in her home in the artist district near Traction Avenue and Hewitt Street

INSIDE THE CHURCH, the light is subdued and watery through green glass windows. Something sacred is usually happening—a baptism, a wedding, a mass—against the tall, broad, gold *reredos* that frames the altar. There might be organ music and hymns sung in Spanish.

IN THE SHALLOW BAY on the left of the altar is a painting of the Virgin of Guadalupe. At her feet are dozens of portrait snapshots of the wounded and sick, each picture pleading for the same grace. In a glass case in the right bay lies a life-sized figure of the dead Jesus, his crucified body waiting for its shroud.

THERE ARE OLDER churches in Southern California and churches more self-consciously historic. The Old Plaza Church wasn't a mission, like San Gabriel or San Fernando. It has been rebuilt and re-imagined so often that not much of it is original, except the part it plays in the life of downtown.

IT WAS LOS ANGELES' only church until the 1860s and its only Catholic church until 1876. Then the city's new Anglo ascendancy built the Cathedral of St. Vibiana in what was a fashionable part of town, away from the Sonoratown barrio north of the plaza.

ST. VIBIANA'S is gone, soon to be replaced by a freeway-oriented cathedral complex on Grand Avenue designed by José Rafael Moneo.

THE LITTLE CHURCH called La Placita will hold on to its huge congregation of immigrant families after the cathedral opens. They will continue to celebrate the cycles of their lives in the one church that has always been theirs.

TOURISTS keep mostly to Olvera Street, where Latino L.A. has been made to seem less intensely real. Not many visitors make the short pilgrimage across Main Street to the Church of Our Lady of the Angels, where they would find downtown's past in its crowded, mestizo heart.

●•●

Neon at night in Chinatown near North Broadway and College Street

DOWNTOWN HAS TWO official seasons. The first one is wet (for a few days in the months from December through March). The second season is dry (all the other days and months).

THE CAREFUL Angeleno knows there are more seasons than the official ones, but their permutations are subtle, like the occultation of planets in an astrological chart.

THERE ARE THE SEASONS of bright (July through August and any day after rain) and seasons of gray (May and June and every day the marine layer lingers). William Faulkner, who hated the place, called the gray light of downtown "a treacherous unbrightness."

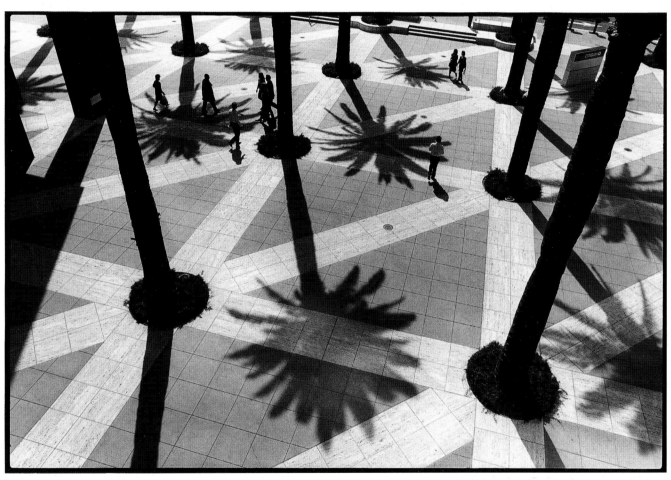

Shadows and light at the Citibank Plaza Courtyard, 5th and Flower Streets

THERE ALSO are seasons of
expectation (November and April,
for example) and seasons of gnawing
regret (the whole month of October,
when downtown's light is too golden
to endure). There are seasons of
fury, when the Santa Ana winds blow
and when L.A. burns. And there are
seasons of sweet-nothing-to-do,
if only we remembered how.

[Sunlight behind the Orpheum Theater sign on Broadway

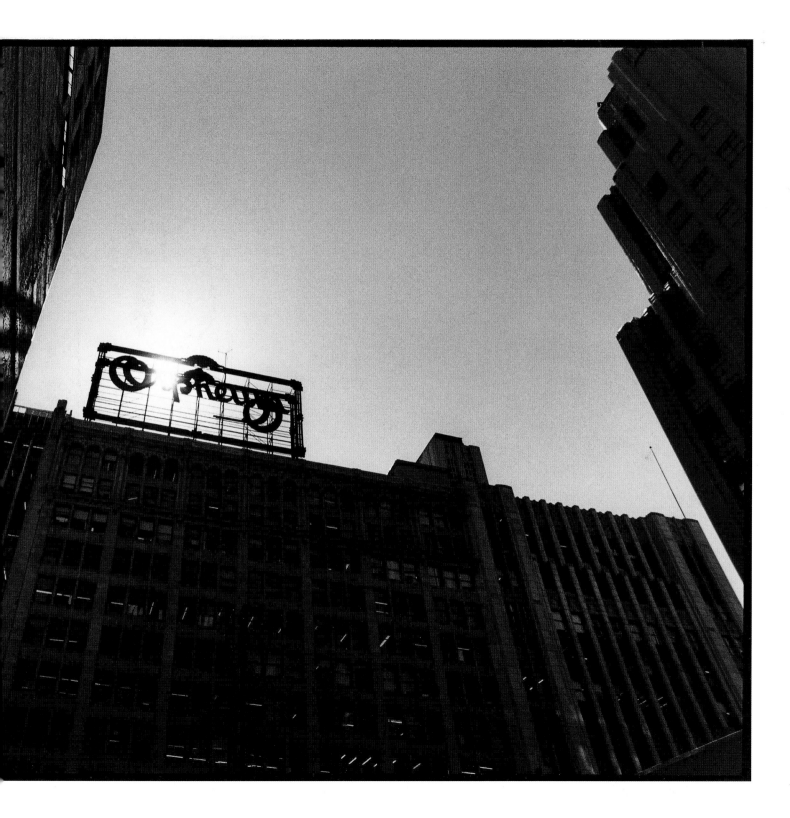

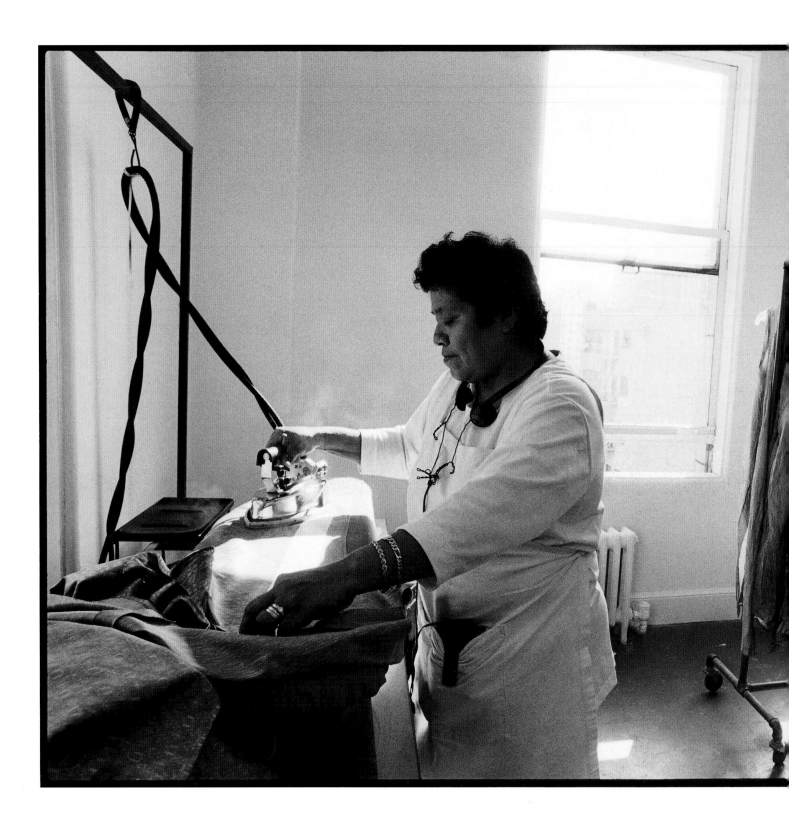

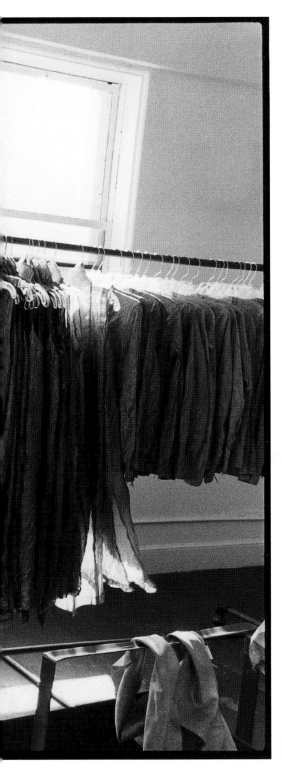

THE DISQUIETING ASPECT 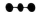 of the
climate of downtown is that nothing
much changes when the light and
air shift from one of their many
seasons to the next, but what has
changed feels permanent.

●•●

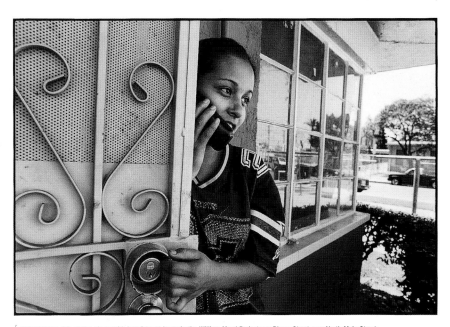

[Esther Vargas, 15, on the phone with her sister at home in the William Mead Projects on Bloom Street near North Main Street

[Delfina Alvarado finishes a garment at Dosa, a clothing manufacturer on Broadway

[Overleaf: Dueling tubas meet at dusk near Temple and Alameda Streets as Boy Scout Band members rehearse

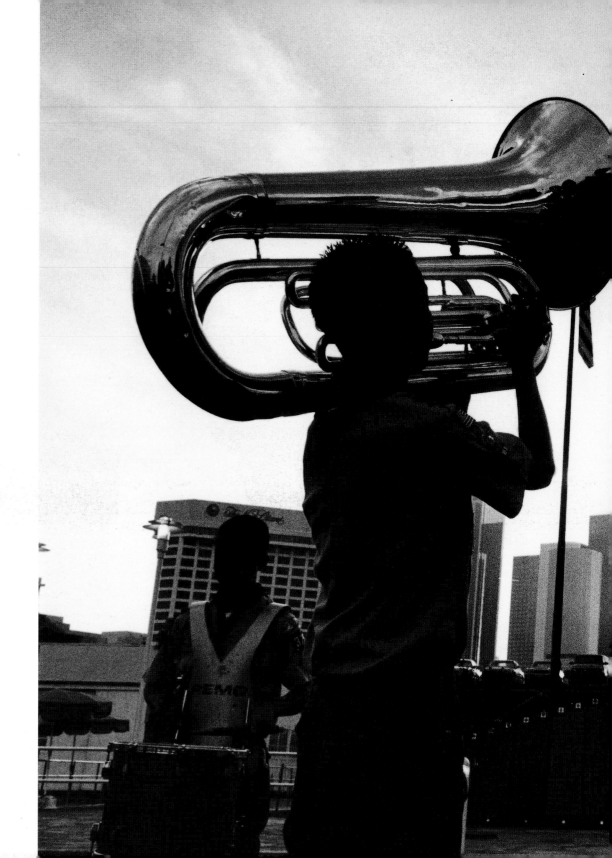

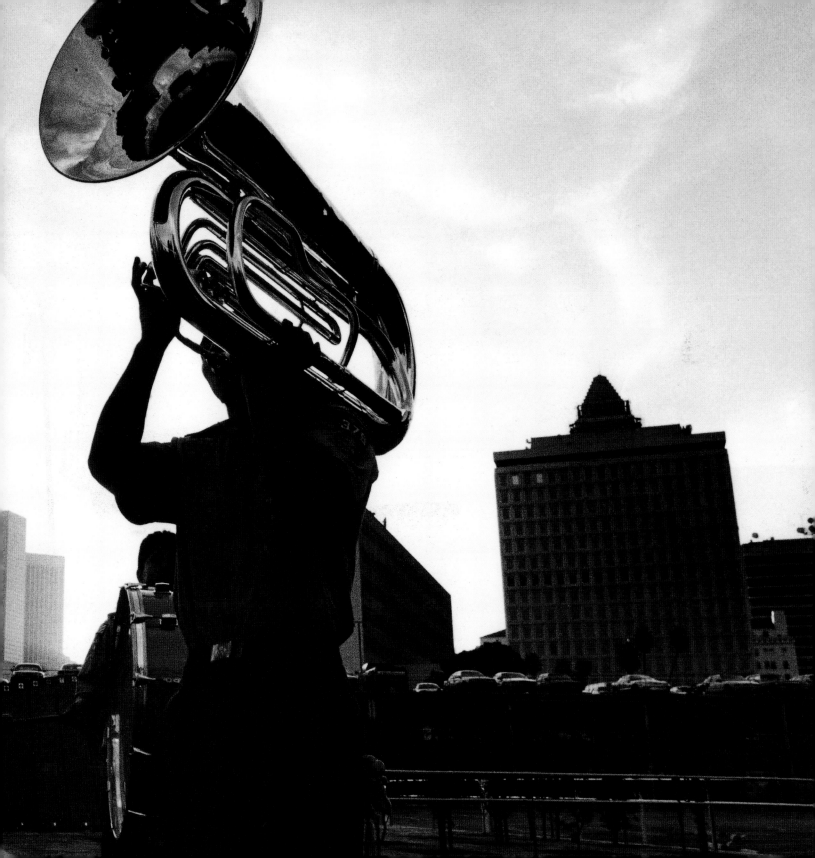

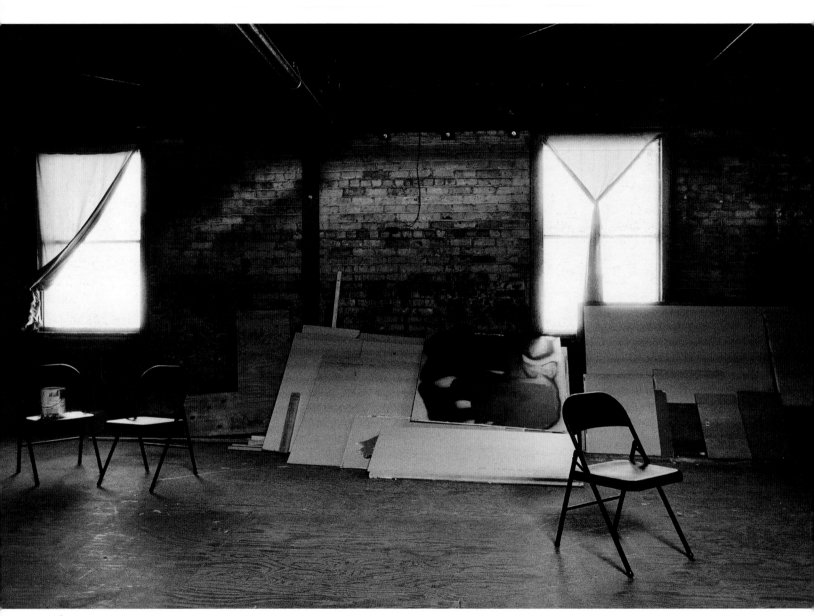

[Southern California Institute of Architecture graduate studies annex on Molino Street

Urban still life on Grand Street

Overleaf: Protesting the Democratic Convention near the Staples Center at Olympic Boulevard and Figueroa Street

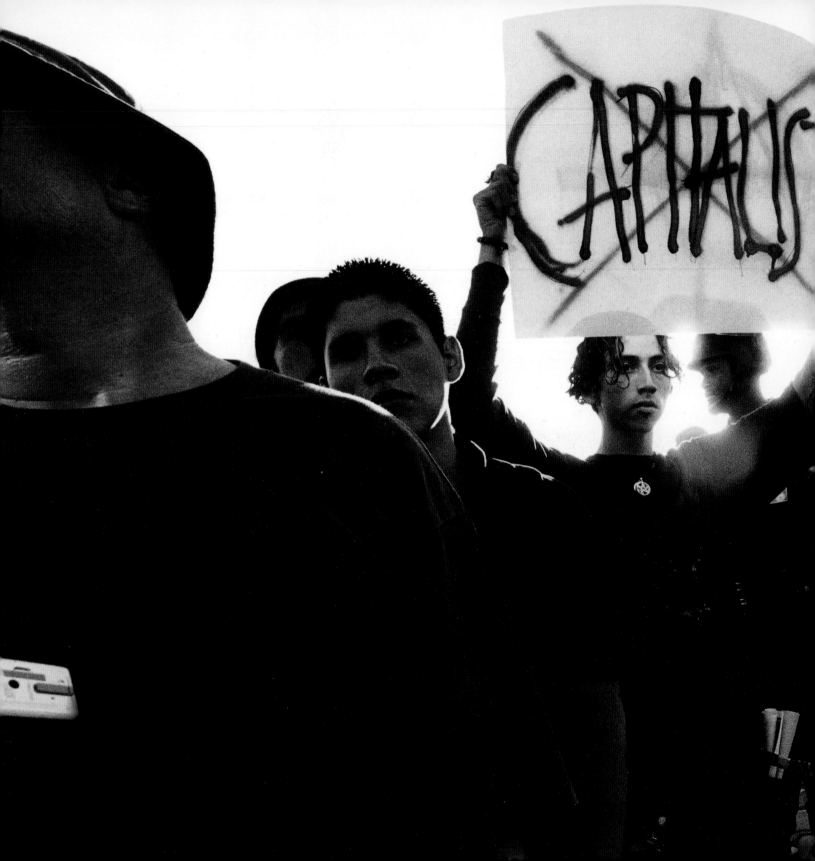

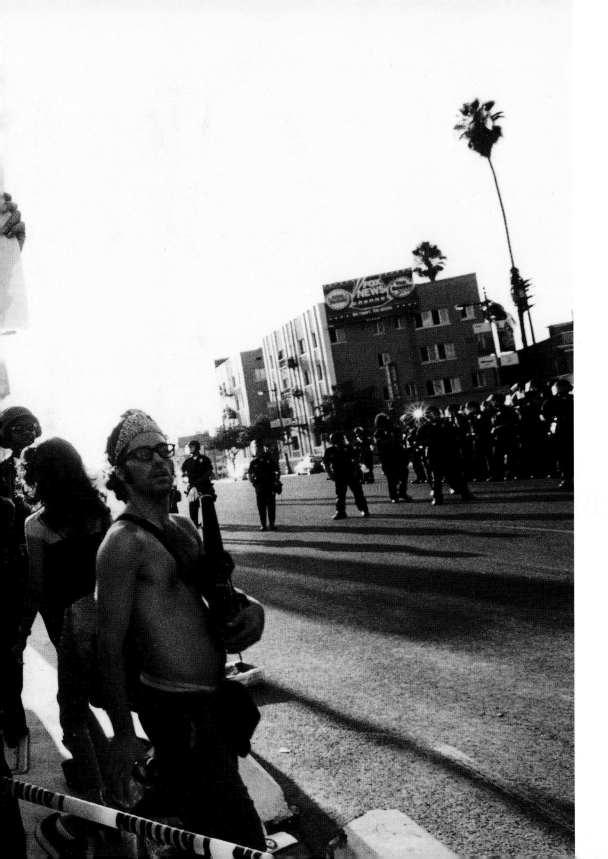

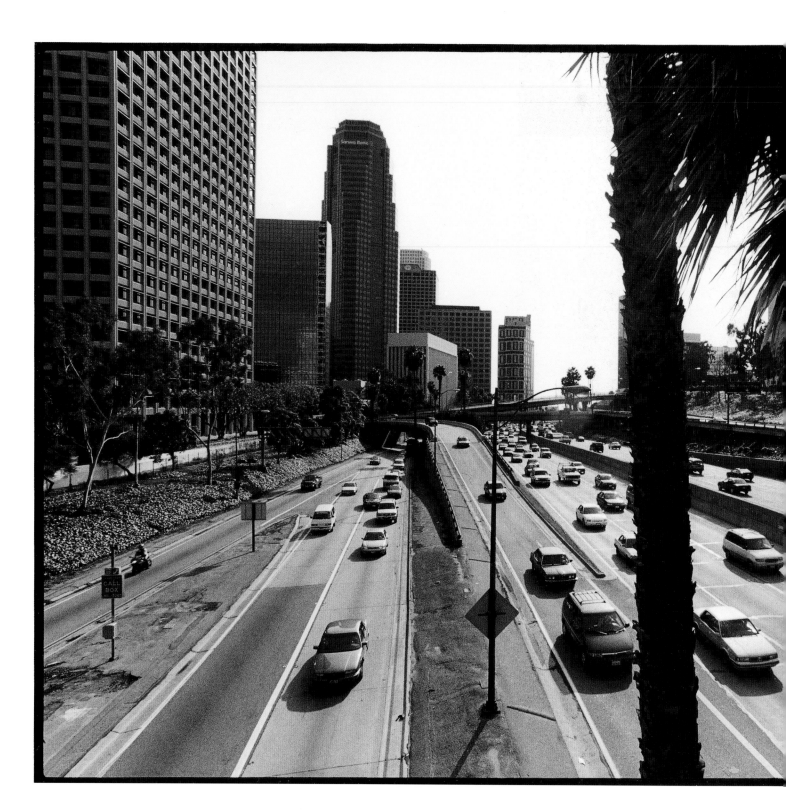

A Great Big Freeway

DOWNTOWN IS TETHERED
to its freeway by
more than off-ramps. In the 1950s,
when downtown was reimagined as
a corporate acropolis, the bundled
arteries of the freeway were
supposed to hold an eastern flank
against immigrant Boyle Heights,
keep in the north the shabby
Mexican and Chinese theme parks
built for the benefit of tourists in
the 1930s, and separate the
homeowners of the suburban west
from Skid Row while redefining
everything south of downtown
as South-Central.

The Harbor Freeway looking southwest from the 4th Street overpass

Overleaf: Actresses Sara Holbert and Nicole Burson prepare for a performance at the Los Angeles Theater Center on Spring Street

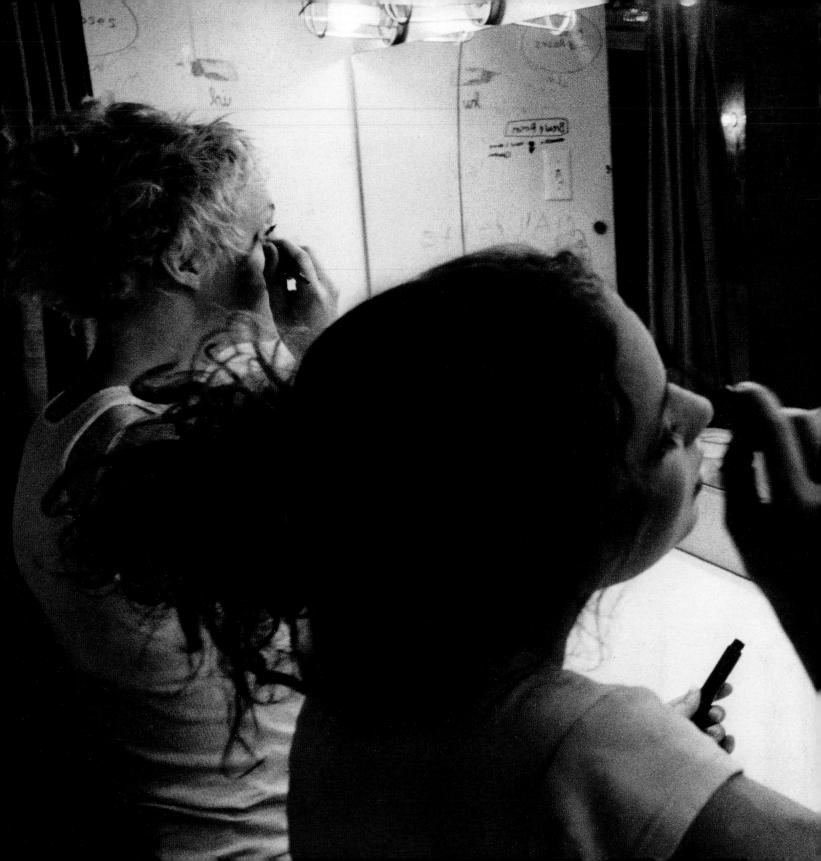

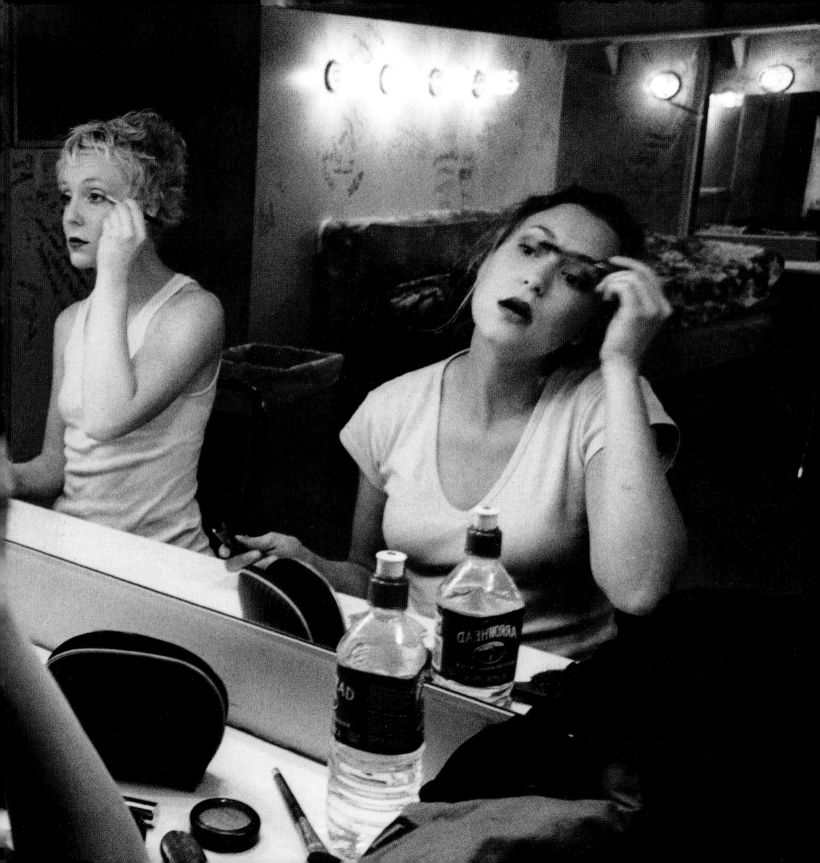

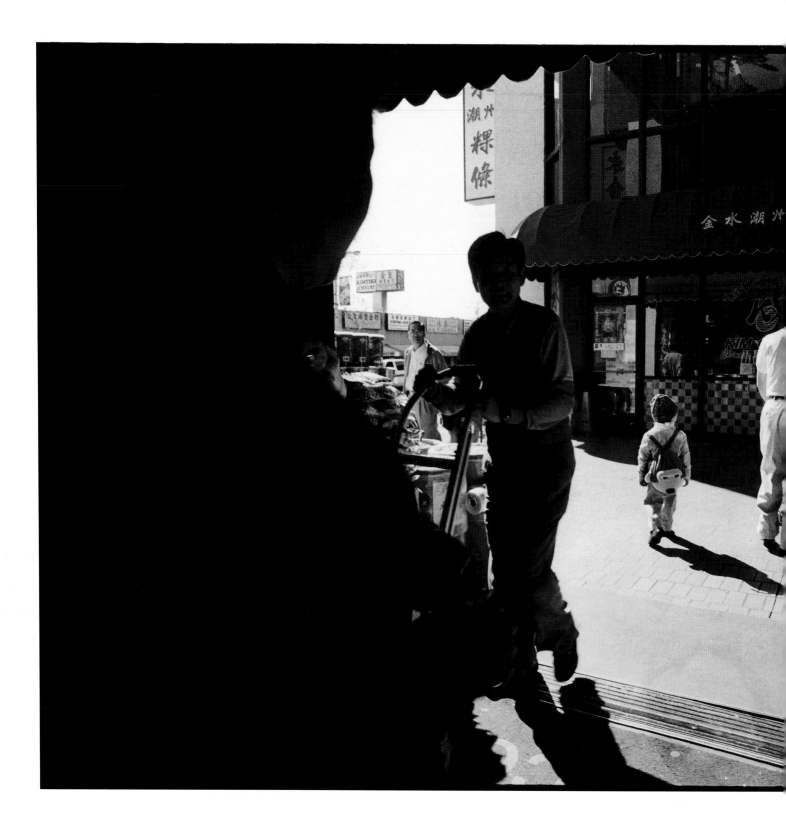

THE FREEWAY that rings downtown
isn't a transportation corridor;
it's a collection of anxious stories
told about the center of the city.

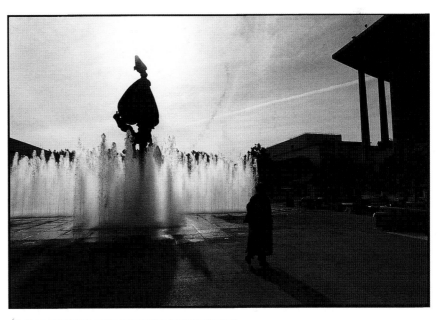

[Looking southeast into the morning sun at the Music Center from Hope Street

[View from the Wing Hop Fung ginseng store on North Broadway in Chinatown

DOWNTOWN TAKES these stories— even the worst of them—and struggles to reweave them into a narrative that accounts equally for the loss and hope the freeway encircles. You don't have to believe in these stories of transformation by immigrant faith, but you should feel the order in them and see the way they might connect to your life across the trough of the Harbor Freeway or the distant elevation of the 10.

[Executive chef Tony Hodges prepares lunch at Checkers Hotel on Hope Street

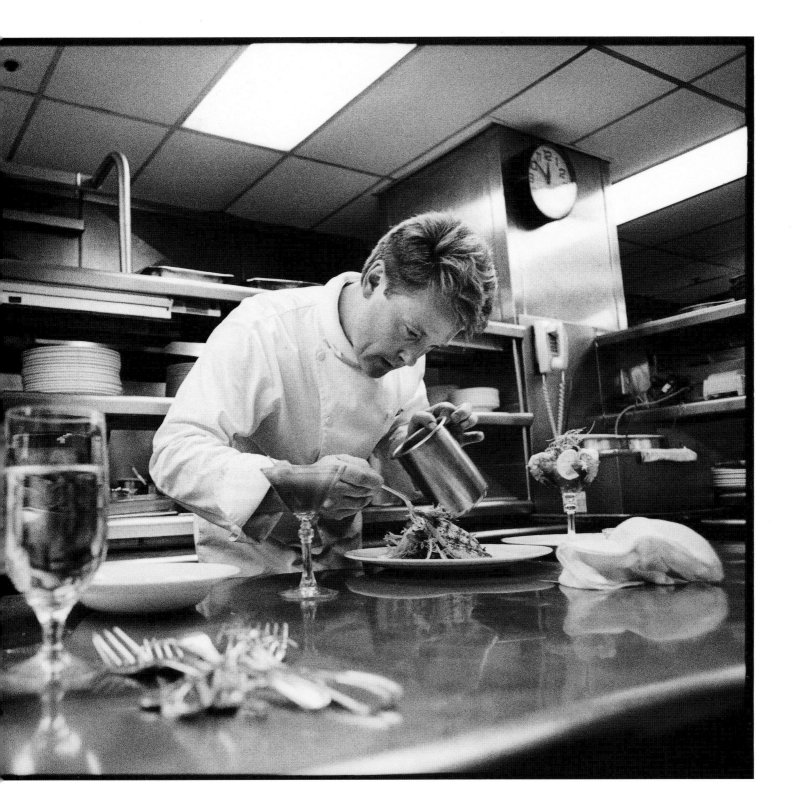

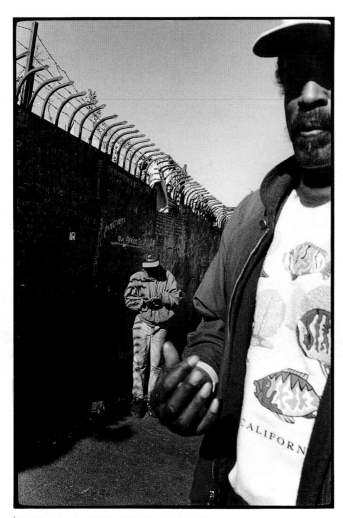

THE BARRIERS to downtown aren't traffic congestion, the burdens of poverty, or downtown's unfamiliar urbanity. It's not even suburban squeamishness. Downtown and the rest of the city, though knotted together by concrete, do not share a common web of stories.

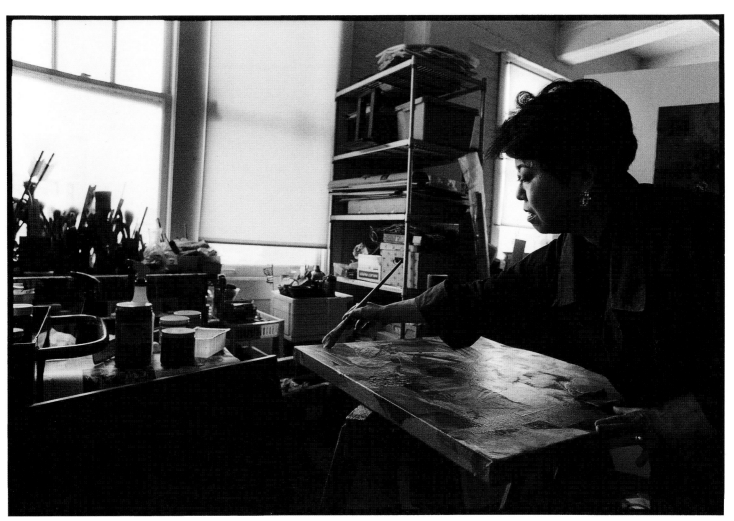

[Artist Nancy Uyemura works on a collage in the loft district near Traction Avenue and Hewitt Street

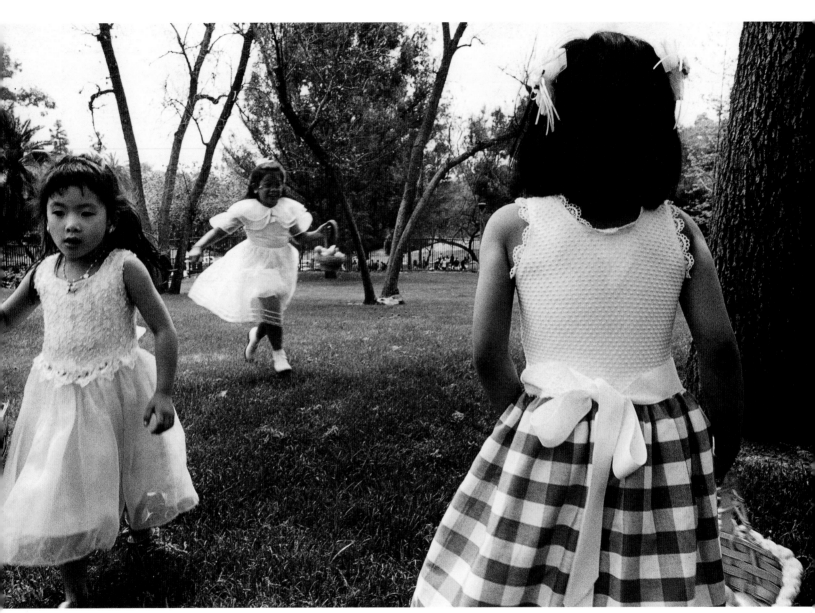

[Filipino children hunt for eggs on Easter Sunday in Elysian Park

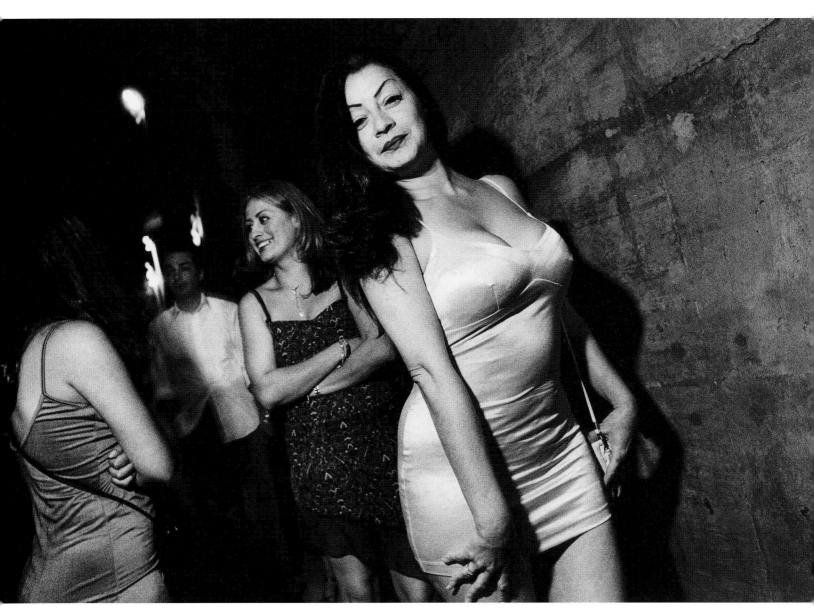

[Waiting to get into Club Soho near 3rd Street

A PROCESS OF DELIBERATE forgetting
made an island of downtown within
its reef of freeway. L.A. is a city
of self-made amnesiacs. Its
remaking as our home—and the
remaking of downtown as a place—
begins with my story told to you,
yours to the Korean who takes your
dry cleaning, hers to the Guatemalan
who sells her fresh fruit, his to
the Jamaican who's waiting for the
bus...a grid of stories overlaying
the broken one that hurries each
of us away from every center.

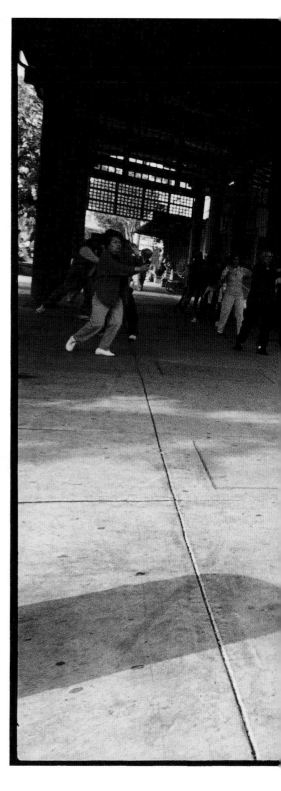

Jack Quon practices t'ai chi ch'uan early on a Sunday morning in Chinatown

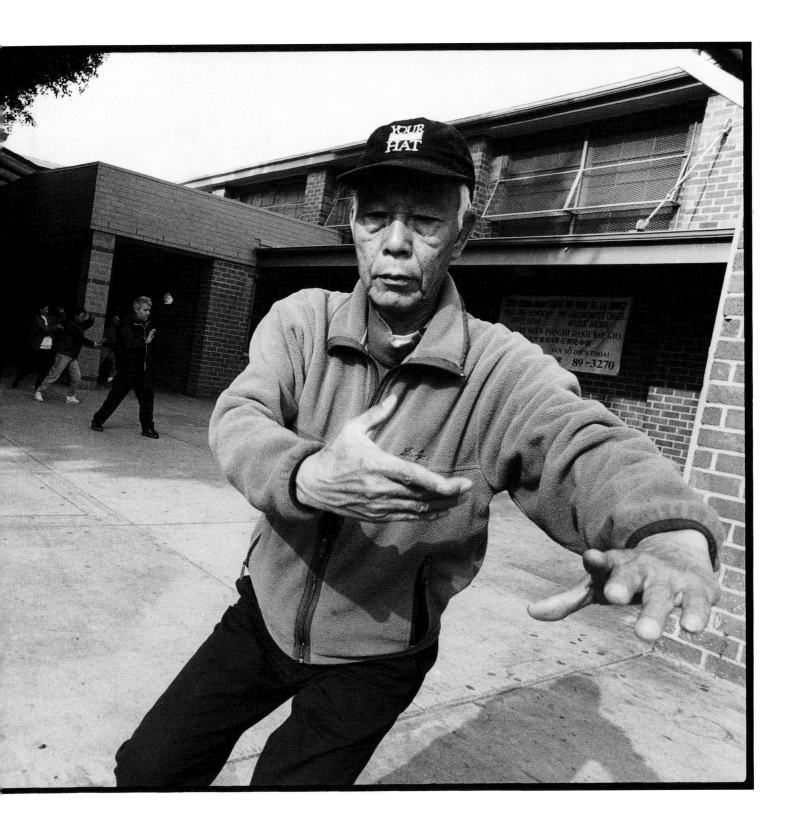

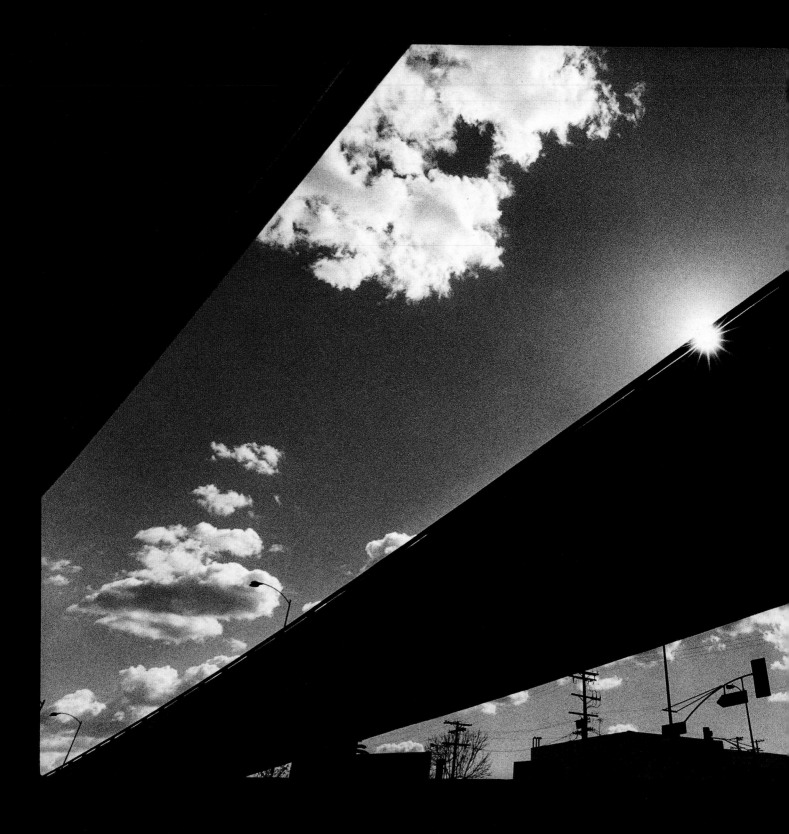

Light, More Light

LAWRENCE WESCHLER,
who writes for
The New Yorker, was thinking about
the light in L.A. He was thinking
about the way it was extravagant
and compelling in late fall, like a
Puccini aria. That it cut out shadows
in dense, black shapes on hot
winter days. Or that it can suffuse
the air with a shadowless, bright
ether called "airlight."

WESCHLER
was thinking how
consistent the light is; that it's
the only thing immune from the city's
regime of speed. The light hangs
in the dry air that masses in front
of the mountains that rise abruptly
behind the city. The thermal
inversion layer overhead dampens
upward heat currents that would
make the light seem to tremble.
One result of the air's immobility
is smog. The other is the still light
of downtown.

[Under Interstate 10 at Los Angeles Street after the rain

WESCHLER WAS THINKING how
the light in L.A. is a substance,
and how it doesn't mark time
but suspends it. He was thinking
of a luminous, dense fluid, more
permanent than the buildings
themselves. He was thinking of
the passage of pedestrians and
cars through this light and how
it admitted and ignored them
equally.

WHEN HE ASKED ME what I thought
of the light in L.A., I added only one
detail—the light, clear as stone-dry
champagne, after a full day of rain.
"Everything in that light is somehow
simultaneously particularized and
idealized," I told him. "And that's
the light that breaks hearts in L.A."

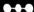

AFTERWORD

THE BUILDING IS THE SAME TERRA COTTA COLOR IT HAS ALWAYS BEEN; A BEACON OF FAMILIARITY CLEARLY VISIBLE from the Interstate 10, looking the same today as it did when we drove past downtown on the way home from Palm Springs when I was a kid. Recently, I stood before the familiar glass doors of that building at 910 S. Los Angeles Street, where my father, a partner in Roth-Le Cover of California, had his office and garment factory for what seemed like forever. Wanting to enter and maybe photograph inside, I reluctantly realized I couldn't go in and couldn't go back. Only my father's memory walks through the doors now.

I choose instead to enter the doors of Sam's Famous Deli around the corner on 9th Street, where I had lunch with my father every day when I worked for him the summer between my freshman and sophomore years in college. On this day, Sam's was half-filled with familiar strangers and I had lunch alone.

As a child, my mother would drive her children downtown southeast along Olympic Boulevard to visit our father in his factory. The journey seemed both endless and grand. We were having an adventure and when I spotted the giant, tiled 76 sign at Figueroa Street, I knew we had arrived.

One of the first publications I worked for as a professional photographer was the *Los Angeles Times*. I covered hundreds of assignments throughout the southland during the nine years I worked there, and learned the ins and outs of all the streets, boulevards and alleys that make up downtown.

In January of 2000, I received a remarkable commission from the Central Library, to photograph downtown Los Angeles. The mission

of the four-month project was to show the vitality and diversity of downtown. The challenge for me was not to be sentimental or cynical, but to produce what I hoped would be an honest portrayal of this complex place.

In order to establish the parameters of this assignment, Carolyn Cole, who curates the photograph collection of the Los Angeles Public Library and I photocopied a page out of the *Thomas Guide* map book, and drew with yellow highlighter the boundaries of what we determined to be downtown Los Angeles: the Harbor Freeway and Bixel Street and Beaudry Avenue to the northwest; the Interstate 10 to the southwest and southeast; the Los Angeles River on the east side; and Chinatown and Elysian Park to the northeast.

Initially, I was somewhat overwhelmed by the scope of the project and wasn't sure where to begin. Raised in our car culture, I realized that I was mainly aware of downtown from the perspective of the driver's seat of my car and had hardly experienced it as a pedestrian. So for the first three days of shooting, I relied on chance; when I came upon a parking space, I pulled into it, and started walking, sometimes for hours. What I saw immediately was that the beauty in downtown is subtle, not overt like New York or Paris, and that the juxtaposition of pedestrians, automobiles and architecture is purely and uniquely Los Angeles.

Los Angeles is the place my parents chose to live after immigrating to the United States in 1938. Los Angeles was chosen for me. Over the years my feelings towards this city have ranged from antipathy to frustration, to resolve and wonder. I built a career photographing around the world, choosing to look outward. But for all of the times I tried to leave permanently, I was always beckoned back here.

This project has been among the most challenging of my career, forcing me to rediscover things I've known all of my life. I found that not only was I looking at the heart of my city, but into my own heart, as well. The irony for me is that at this point in my life, I have made my peace with Los Angeles, and have learned to love it from the inside out.

Marissa Roth
Los Angeles, March 2001

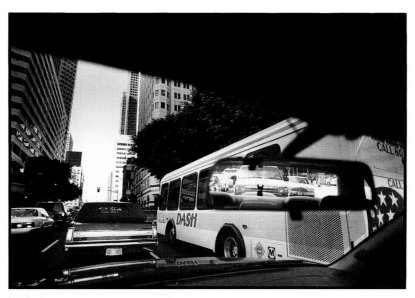

Doggie in my window

ACKNOWLEDGMENTS

REAL CITY came about as a result of a photographic commission that I received in January of 2000 from the Los Angeles Public Library for its "Neighborhood Project." The assignment was to photograph downtown Los Angeles for four months, and produce sixty images that would first be exhibited at the Central Library and then placed in the Library's permanent photographic archive.

I would like to thank Susan Kent, City Librarian, and Carolyn Cole, who curates the Library's photograph collection, for this unique opportunity. In addition, I would like to thank Melissa Richardson Banks, Director of Sponsorship and Marketing for the Library Foundation of Los Angeles, and Toria Aiken, Exhibitions Coordinator of the Los Angeles Public Library. Special thanks go to Farmers Insurance Group for sponsoring the original photographic project, "Inside/Out: Downtown Los Angeles," that was exhibited at the Central Library from July 1 to September 24, 2000.

For introductions, walking companionship, encouragement and assistance, I would like to thank Jon Thurber, Alice Callahan, Aimee Liu, Stephen and Mus White, Ron Roth, Roseann DeLuca, Graham Howe, Sheila Pinkel, Michael Dawson, Tom Mobley, Gilles Mingasson, Scott Sandell, Roger Roth, Denise Hamilton, Carol Fulton, Christine Kim, Rachel and Mark Kreisel, Pat Downs, Iris Schneider, Paul Feldman, Judy Lapin, Ruth Gilbert, Robin and Kenny and Brittany Roth…and Miles.

A heartfelt thanks to Don Waldie for his extraordinary prose, and a special thanks to Lawrence Weschler for introducing me to Don.

Special thanks go to the law firm of Gibson, Dunn & Crutcher LLP, for their generous support of this book.

For making this book possible, I would like to thank Angel City Press's Paddy Calistro, Scott McAuley and Sheila Perkins; my literary agent Martha Kaplan; Richard A. Semon for legal assistance; and especially graphic designer Maritta Tapanainen.

The photographs were made between February 2000 and February 2001, and wouldn't have been possible without the kindness and support of strangers and friends both old and new.

— M.R.

The *Los Angeles Times* Book Review and Opinion sections have encouraged my recent consideration of downtown. Grateful acknowledgment is due Janet Clayton, editor of the editorial pages, and Gary Spiecker, deputy Opinion editor, who has edited my commentaries, and to Book Editor Steve Wasserman and Deputy Editor Thomas Curwen, who have edited my reviews.

— D.J.W.

ANGEL CITY PRESS gratefully acknowledges the following organizations:

LOS ANGELES PUBLIC LIBRARY This book features photos from the Los Angeles Public Library's "Neighborhood Project." Created in 1996 by Photo Friends, the project utilizes commissioned photographers to create visual records of Los Angeles's diverse communities in the early years of the new millennium. Photographs from the Neighborhood Project augment the Library's major collection of more than 2.5 million images. With its Central Library, sixty-seven branches and four bookmobiles, the Los Angeles Public Library serves the largest population of any library system in the United States. Established in 1872, it strives to inform, enrich and empower people by offering free access to information and by providing lifelong learning opportunities.

LIBRARY FOUNDATION OF LOS ANGELES Founded in 1992, the Library Foundation of Los Angeles secures private funds and offers marketing support to enrich programs and services of the Los Angeles Public Library. To support the Los Angeles Public Library, call the Library Foundation at (213) 228-7500.

GIBSON, DUNN & CRUTCHER LLP Gibson, Dunn & Crutcher's roots in downtown Los Angeles stretch back to 1872 when its founder arrived by stagecoach to begin his law practice in what was then a dusty pueblo of about seven thousand inhabitants and 110 saloons. Since that time Gibson, Dunn has been a continuous resident of downtown and a participant in its change and development as an occupant of no less than nine downtown office buildings, including the historic Bradbury Building and the Banks, Huntley Building at 634 South Spring Street. That building, which the Firm occupied from 1930 to 1972, is now the headquarters of the Mexican American Legal Defense Fund, thus symbolizing in its own singular history the relentless change beautifully captured by Marissa Roth's photographs and D.J. Waldie's text. Gibson, Dunn is proud to be a sponsor of REAL CITY.

["The Travel Angel," by Dean and Laura Larson, at the Central Library